HAUNTED GUTHRIE, OKLAHOMA

TANYA McCOY AND JEFF PROVINE

Haunted America

Published by Haunted America

A Division of The History Press

Charleston, SC 29403

www.historypress.net

Copyright © 2015 by Tanya McCoy and Jeff Provine

All rights reserved

Unless otherwise noted, all images appear courtesy of Jeff Provine.

First published 2015

Manufactured in the United States

ISBN 978.1.46711.806.4

Library of Congress control number: 2015943192

To Clinton and Courtney

CONTENTS

PREFACE

Paranormal investigation, or as some like to call it, "ghost hunting," has been around for centuries. The first organized ghost club was formed in London around the 1860s to help bring scientific methods to the study of paranormal phenomena. In the 1880s, the interest in paranormal studies reached New York and spread across the United States. Paranormal research has continued to capture widespread attention, but it wasn't until recent years that ghost hunting started to increase in popularity.

With the launch of several new TV series, paranormal investigating became an overnight sensation. More and more people have begun to believe in the possibility of haunting, and those who were too afraid to speak out about possible paranormal activity in their homes or businesses no longer faced public ridicule. As people became more comfortable sharing their experiences and reaching out for help, paranormal investigation teams began popping up everywhere. While some simply want a thrill, others truly look for answers and to help others who are experiencing paranormal activity. This influx of people now wishing to investigate haunted locations has unfortunately resulted in many businesses and property owners finding themselves the victims of breaking and entering or people trespassing on their private property. Buildings have been vandalized and, in some cases, totally destroyed. Many haunted locations that once welcomed investigative teams are now closed to investigators due to other people carelessly damaging the property they were once invited into.

As paranormal researchers, we seek answers to help solve why there may or may not be paranormal activity at a certain location. When we are offered a site to investigate (for which we never charge our hosts), we take in a team of trained investigators and cases of equipment and log thousands of hours to try to find answers that will help the home or businesses owners. For some, this is a chance to find closure. For everyone, it is a time to explore the question of what happens when our mortal bodies die.

We are often asked how we can know for certain if a place is haunted or even if ghosts exist. The answer is quite simple: we can't. We can have our beliefs, our feelings and even our senses to help us conclude in our own minds whether a place is truly haunted, but even with all of the new technical equipment made to help us gather evidence of paranormal activity, it is all just based on theory in the end.

I have seen spirits since I was six years old. Many of my sightings have also been witnessed by someone else at the same time. Does that prove ghosts exist? To me it does, but to others who have not seen the same things, it does not. At the end of the day, everyone has his or her own beliefs. What you choose to believe is up to you.

Since the night I witnessed my first spirit, I have been drawn to investigating the paranormal with the need to find answers. When the chance arose to join a paranormal team, I was thrilled. I had spent years reading and researching some of methods used by some of the well-known names in the paranormal field of research. I spent a few years with the team and then decided to branch out with a team of my own, the Oklahoma Paranormal Association (OPA).

A year later, I met Dee Parks, also the founder of her own team. We hit it off from the start, and I asked if she would like to join forces. We both felt the need to offer a class on paranormal investigating for people who were wishing to start teams of their own. The rise in new teams and lack of education on how to properly conduct an investigation was causing many haunted locations to refuse access to paranormal researchers. We hoped a formal class would help to decrease the number of people breaking and entering and trespassing and also teach others to respect the spirits we visit. Already we have seen great success, and our class also provides the chance for people who would not normally investigate a haunted location to join us and learn how to conduct an investigation with the same equipment we use.

The equipment we use can be very costly, but those first starting out don't need to invest huge amounts. A simple compass is a tool that can detect a magnetic field disturbance. Dowsing rods can be used to ask questions or

even locate an energy force. A pendulum can help answer questions as well. All of these can be purchased for less than fifteen dollars.

A digital camera and audio recorder can be a paranormal researcher's best friends. I remember the excitement I felt when I caught my first electronic voice phenomenon (EVP) and my first picture of a spirit. Many people have these kinds of equipment in their everyday lives, and those who want to invest in their research may do so by recording straight to terabyte-sized DVR drives with night-vision or infrared cameras.

With the increase of interest in the paranormal, new equipment is being invented all the time to help researchers collect evidence, such as the KII, temperature guns, FLIR guns, parascopes, Mel meters and Gauss meters. These can become very costly. One of the most popular pieces of equipment we use costs around $300 and translates energy field flux into words.

For those not wishing to spend so much money, there is an alternative app available for smartphones, which already have built-in EMF detectors. Designed by Swedish app publisher Exelerus AB, Ghost Radio can be downloaded to a phone for a fraction of the cost of other equipment. I had never put much faith in phone apps used in paranormal investigating before, but I must say this app has actually given us the same information the more expensive piece of equipment did, saying things that an app would simply not know. Those who have downloaded it are usually quite happy with the results, and the app's inventors are polite and eager to work with others in developing further apps.

Investigators may spend thousands of dollars on equipment, but the best tools are one's own senses. The environment is the best indicator of any possible paranormal activity. Investigators should always be aware of their surroundings and note that any changes may be mundane as well as supernatural.

THE PARASCOPE

Created by Jeremy Jones, the proprietor of Paranologies, the parascope is a triboelectric meter made up of a small square base with several clear plastic rods standing straight up, which lights up in rainbow colors. The parascope detects different voltages of electricity in the surrounding air. We all have static electricity in our bodies, and Jones designed the meter in hopes that we carry the electricity with us when we pass on. Unlike the KII or other Mel

meters, which pick up on man-made energy, the parascope is designed to detect free-floating static electricity and display its path of travel by lighting up the clear plastic sticks on top. In our investigations, we place these in the areas where we tend to see a lot of shadowy figures or movement. I found them to be very effective, and they are quickly becoming one of my favorite pieces of equipment.

EMF DETECTORS

There are several different types of EMF (electromagnetic field) detectors. The best known and widely used is the KII, a brand name made popular though exposure on many paranormal television shows. According to many paranormal researchers, spirits produce a magnetic field of energy. It is widely believed that the spirits can control the levels of the magnetic field at will and can manipulate the equipment to light up when present. The KII consists of an LED light-up scale. Unlike other EMF meters that can measure static EMF fields, the KII can measure only magnetic fields. When the KII comes in contact with magnetic energy, it is transduced into electrical energy, which becomes amplified, in turn lighting up one or more of the LED lights with intensity depending on the energy levels. This helps the researcher to obtain answers from the spirit world by asking a spirit to answer questions by lighting up the LED lights. For example, if an investigator asks the spirit to please light up the lights if it is a female, but the KII fails to light up, that may be a "no" answer. If the investigator then asks it to light them up if it is a male, and it does, then the investigator can draw the conclusion that the spirit is male.

A KII is a great tool to use when researching the paranormal, but an investigator must also be aware of receiving a false-positive reading. The KII measures magnetic fields and is not programmed to receive them from only the spirit world. There are several other sources that can give a false positive, such as a cellphone. Receiving text messages, e-mails and updates can cause the KII to light up. The best practice for an investigator is to put all smartphones on "airplane mode" and be aware that they may still produce false-positive readings. Other sources known to give off false-positive readings include copper wiring, CB radios, emergency vehicles, lights in the ceiling and walkie-talkies. It is best to be aware of all surroundings and do a base reading of the locations.

The FLIR

The FLIR is a name brand for an infrared camera used to detect heat signatures or forms of energy. It then converts this into an electronic signal, which is then converted into a thermal image. There are a number of different settings investigators can use, but the two most popular are the rainbow scale and the gray scale. The rainbow scale shows the difference in temperature from hot to cold, but we often prefer the gray scale, which works well for capturing shadow figures. The FLIR can be a good piece of equipment to own, but it can be very expensive for someone just starting out.

Temperature Gun

Another piece of widely used equipment is the temperature gun. This piece of equipment can run anywhere from forty to sixty dollars and can be found at local home improvement stores. The temperature gun is used to help detect any temperature changes in the air. It is believed that, for a spirit to manifest, it must first collect energy to gain strength to interact. Many believe spirits can take energy straight from the atmosphere, causing a noticeable drop in temperature that is often described in ghost stories. Investigators should be aware of any windows, doors, fans or A/C units, all of which can affect the temperature of the room.

ACKNOWLEDGEMENTS

Special thanks go out to all those who helped in the research for this book by offering their time for interviews, sites for investigation and leads on where to look. There are so many to name, especially Dee Parks, co-founder of Oklahoma Paranormal Association (OPA); James Long, owner of Addison Suites Bed and Breakfast; Stacey Frazier of the Guthrie Ghost Walk; John Pagonis at Guthrie Haunts and Guthrie Scare Grounds; Christine Dawson, lead investigator of OPA; Veronica Wagner, case manager and lead investigator of OPA; Greg Rupert of the American Legion in Guthrie; Bob Bozarth; Cynthia O; Nelda Brown and the Guthrie Genealogical Society; Nathan Turner and the staff at the Oklahoma Territorial Museum; Becky Luker and Michelle at the Stone Lion Inn; Laurah Kilbourn and company at the Extra Special Fabric store; all the women and men of the American Legion Hall Addison Suites; and the OPA team members.

Tanya would like to thank most of all her wonderfully supportive husband, Clinton Womack, who has helped her realize and accomplish her dreams as well as supported her along the way.

Jeff would like to thank his wife, Courtney Oliphant, for her understanding and encouragement during late nights and weekend research trips.

GUTHRIE'S LINGERING PAST

Guthrie! There is magic in that name, Whenever anyone anywhere in the world, at any time, thinks of the great southwest, or the wonderful new state of Oklahoma, the name of Guthrie is instantly telegraphed to the front rank of the thought.
—1910 Review of Industrial & Commercial Guthrie

Few places in the world hold the charm of Guthrie, Oklahoma. Once the shining capital of America's last frontier on the Great Plains, today it still shines like an unearthed treasure. Its tale is one of immense promise, betrayal by fate and a return to wonder as one of the best-preserved and most beautiful man-made places in the world.

Guthrie is frozen in time from the heroic American fairy tale of the Wild West. Thousands of visitors flock there every Christmas to see the legends come to life with the Victorian Walk. They stroll among costumed actors in century-old storefronts of unique brick buildings from the mysterious architect Joseph Foucalt and take in a showing of *A Territorial Christmas Carol* at the Pollard Theatre. Thousands more visit year-round for festivals, rodeos and simply to get a taste of the magic of a seemingly ancient city.

It is humbling to think that, 125 years ago, the town of Guthrie was little more than rolling country hills. The area was populated by buffalo herds and Native Americans who made a living through hunting them. Only a few trees grew near the creeks, and the rest was wide-open prairie with horizons that stretched for miles.

The entrance to Guthrie off Sooner Road, where a car heading south once whisked away the state seal.

Yet white explorers in the nineteenth century were not impressed. As described in his report following his expedition up the Platte River to the Rockies and then down the Arkansas River, Major Stephen Harriman Long took a group under his command to march south and seek the Red River. Instead, they met intimidating Native Americans and headed east until they arrived back at Fort Smith, Arkansas. The journey was so difficult that they had to eat their own horses. Long dubbed the land "The Great American Desert," perhaps out of guile to discourage European settlement or perhaps simply out of spite. Botanist Dr. Edwin James, one of the scientists on the expedition, stated that what would become Oklahoma was "unfit residence for any but the most nomade [*sic*] population."

Despite James's words, permanent settlement would indeed come to Oklahoma. In the 1830s, the Indian Removal Acts created Indian Territory with Guthrie being part of the land demarked for the Muscogee (Creek) nation. As their homeland was today what is eastern Alabama, the wooded eastern part of the territory was more suited toward the Creek lifestyle than the plains, which left the west largely unpopulated. Many Creek tribes allied

themselves with the Confederacy in the Civil War; others, such as those under Opothleyahola, campaigned for the North. When the war was done, the whole Creek nation was made to sign a new treaty allowing the federal government to purchase much of their western land. Indian territory was restructured to forcibly settle more tribes, but a huge area in the middle remained empty and was dubbed the Unassigned Lands.

While legally nebulous, the Unassigned Lands were hardly vacant. They were most infamous for harboring outlaws. More benevolent were the cattlemen, driving their fattened herds north to the rail lines in Kansas. After the Civil War left much of the eastern agriculture in ruin, the beef of Texas became a gold mine, if only it could be delivered. Jesse Chisholm carved his trail through the territory along what is roughly Highway 81, just west of Guthrie, and millions of cattle that were worth three dollars a head in Texas were sold for upward of fifty dollars in the East.

Others thought that the land should be opened up for settlement. Cattlemen balked at the idea of losing their highway to the north, and Indian tribes were concerned about new encroachment on their lands. Congress reviewed and tabled bill after bill through the 1870s seeking an organized "Oklahoma." It was touted as fertile land just waiting for economic development, but others would not deign to see it open.

Where politicians debated, others chose to move. The first was Elias Boudinot, a former Cherokee and nephew of General Stand Watie. Boudinot's 1879 letter in the *Chicago Times* boomingly called for settlers to move into the Unassigned Lands. Since the area was public land, he argued that it fell under the Homestead Act of 1862, which granted 160 acres to eager settlers. While Boudinot's legal arguments fell through, they encouraged other people to act. Colonel C.C. Carpenter spread the word in Kansas newspapers that he was ready to lead, and plenty followed him. President Rutherford B. Hayes issued a declaration from Washington that the land was not, in fact, open and that anyone attempting to settle would be removed by military force. Carpenter's followers disbanded, confused by the inconsistent notices and deciding to believe the president. The proclamation did not stop other Boomers under Captain David L. Payne and his second-in-command, W.L. Couch. Hundreds of people moved into Oklahoma and were subsequently marched out by U.S. Cavalry.

Meanwhile, the railroads expanded, and lobbyists for the cattlemen to keep the Unassigned Lands closed were replaced by lobbyists for the railroads who wanted it open. Congress had a difficult issue to overcome. According to the 1866 treaty with the Creeks, the land had been earmarked

for future tribes and the freed slaves of the Creeks and Seminoles. A proposal to give the whole land to slaves was proposed in 1882 after the formation of the Freedman's Oklahoma Association, but the project never materialized. Instead, Congress had to produce an entirely new treaty with the Creeks that would make the land truly free and clear.

At last, President Benjamin Harrison signed legislation on March 22, 1889, that officially determined the Oklahoma District would be opened for settlement in one month. At noon, the land would be settled through a novel practice: a run. Progressive ideals determined that those most fit to have the land would be the ones most eager to get there. First come, first served.

The announcement was a godsend to people seeking a second chance, especially farmers. After a decade of economic slowdown with fewer and fewer railroads being built, the Panic of 1887 caused bankers to call in debts. Much of the East considered it a minor recession, but farmers in the West who had been borrowing at 20 or even 40 percent were wiped out. From 1889 to 1893 in Kansas alone, eleven thousand mortgages were foreclosed. Many had to leave farming altogether, going to work in towns and cities. Those who stayed on the mortgaged farms lost ownership of the land, and a quarter of all those employed through agriculture became tenants to large landholders.

Now, just a bit to the south, a whole region was opening up for settlement with 160 acres for no more than the ten-dollar filing fee. The conditions for the Land Run were straightforward and benefited the disenfranchised. A homesteader needed to be only twenty-one years old, although heads of households could be younger, which encouraged hardy young folks to try their hands at the new land, especially those seeking to raise a family. Women and immigrants were welcome. Anyone who already owned 160 or more acres was not welcome. Union veterans of the Civil War could deduct their service time from the required five years of staying on the claim to gain clear ownership. Thus, anyone needing land who had the gumption to race for it and "prove it up" with crops and a home over the course of five years now had the opportunity to do so.

While farmers were eager to have their hands on 160 acres, other settlers were more interested in the smaller "town lots" in the areas designated for townships. Farmers needed places to buy goods and sell their crops, not to mention services from restaurants to barbers to banks, blacksmiths and more. Settlers hoped bustling cities would grow out of the prairie.

The most sought-after site was called Guthrie. It sprang up as "Deer Station," a stop on the Santa Fe Railroad line that practically bisected the

district. In 1887, Deer Station was renamed in honor of John T. Guthrie, a Civil War captain and lawyer. After the war, John Guthrie moved to Topeka, Kansas, where he had a prestigious career as an attorney for the railroad. He entered politics, was voted Speaker of the House in the Kansas legislature and missed being elected governor by four votes in 1876. A strong Republican, he was appointed Third District judge for Kansas as well as postmaster for Topeka by Presidents McKinley and Roosevelt. The railroad named its station out of pride for Judge Guthrie, who visited it just once, on the day of the Run, as an observer in one of the first trains.

Settlers had a long list of reasons for wanting to set up shop in Guthrie. It automatically became one of the principal sites in the Oklahoma District with one of two U.S. Land Offices. The other was at Kingfisher Stage Station on the stagecoach route, but Guthrie had the railroad, too. It also had Cottonwood Creek, a readily available source of water, which would prove invaluable in the "Great American Desert." The most lauded reason was that the federal government announced that the site would serve as the territorial capital (even though Oklahoma Territory wouldn't be organized until May 1890). The thought of a capital springing up on the plains excited the imagination and drew in immediate business, such as the *Oklahoma Capital* newspaper, which began thirteen months before there was a capital for Oklahoma.

As April 1889 rolled on, eager would-be homesteaders flooded the Kansas border, Indian Territory and north Texas. Following laws of the open market, prices skyrocketed for supplies like tents, cooking utensils and dry goods. Merchants eager to make a profit brought in strong horses and mules from as far away as the Dakotas. It came to the point where horses became priceless: no matter how much was offered, no one would sell the advantage in staking a prize claim that came with a fast steed.

In addition to runners, settlers eager for a town lot rode the train. Within the first three hours of the noon cannon firing to signal the start of the Run, eight trainloads of settlers from Kansas were dropped off in Guthrie, with still more coming in from Purcell in the south. Some estimate the number of people brought to Guthrie by train was as much as ten thousand, which was about half of the twenty thousand who rode the train on the Run throughout the whole Oklahoma District. Another twenty thousand arrived on horseback, in wagons, on bicycles and even on foot.

The sun set on the weary runners, but few were able to sleep. Wild hoots and gunfire rang all through the night as men excited for their claims celebrated violently. No one is recorded injured, but many already

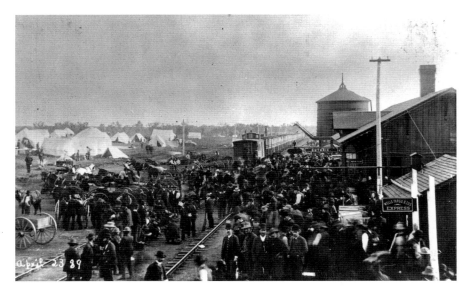

The Santa Fe Depot bustles with new settlers one day after the Land Run. *Courtesy Bob Bozarth Photography.*

unsure about the wildness of the West might have felt that their fears were realized. Yet the commotion was all in fun. In a back-and-forth similar to today's "Boomer...Sooner!" a few miles south in Norman, men would call out, "Oh, Joe!" Anyone within earshot would eagerly cry back, "Here's your mule!"

As soon as sunlight broke in the east on April 23, a call was given for the establishment of a provisional government for the newborn town. Four thousand people showed up to the meeting, and elections were held out of the backs of wagons. They quickly established a source of revenue by outlawing gambling with a penalty of $5.00. The fine didn't deter too many players, such as those at the Reeves Brothers saloon, and it proved practically to be a tax. More formal taxes were laid on peanut venders ($1.50 per month), banks ($50.00 per month), entertainment shows ($100.00 per day) and billiards ($3.00 per month per table).

After the madness of the Run settled, problems instantly made themselves known. With large sections to claim, many people unknowingly claimed the same lots. A council was set up to determine who had proper title to them, but verdicts were difficult. One farmer who legitimately claimed 160 acres on the east edge of Guthrie found his land plagued by spillover townsfolk who had measured out and claimed town lots

out of his land on their own prerogative. A federal judge in Muskogee ultimately decided that the needs of the many outweighed the needs of the few, which proved to be one of many unpopular decisions. The stress and a couple forced resignations over ordinances that gave lots to friends left the judicial council with a turnover rate measured in weeks. The site of the Land Office, now Guthrie's U.S. Post Office, was packed with claimants frustrated by long waits and dense crowds. Fights broke out so routinely that it became known as Hell's Half Acre.

Some issues of multiple claimants had straightforward solutions. Charles F. Ashinger and Katie Woodruff fought over a quarter section of land southwest of Guthrie. Ashinger swore that he left the train arriving from Purcell at 2:10 p.m. and staked his land at 2:13½ p.m. Woodruff's lawyers pointed out that the distance was impossible to cover in such a short time, calling Ashinger a liar and a "Sooner." Ashinger, as it turned out, was a world-champion in foot racing. One hundred people watched as he won his case by lining up at the station and sprinting the whole distance in three minutes, twenty seconds, proving his run with time to spare.

Other rival claims were more difficult to sort out. Fortunately, there was no shortage of lawyers to aid '89ers with their problems in court: some 215 had come into town to set up practice within two months. A wide arc of wooden crates serving as desks around the Land Office made up a wall of potential legal advice. Gradually, would-be settlers discovered that many of the lawyers had neither passed the bar nor even studied law before.

Beyond the issues of supplies and whose land was whose, Guthrie suddenly had a population of some fifteen thousand and no civil services to support it. In fact, surveyors had forgotten to lay out streets, meaning people were walking across everyone else's land to get anywhere. The councilmen

Guthrie hosts the smallest national park in the United States. Just eight by six feet square, the oak stands as the site of the original Land Office.

21

appointed C.C. Howell as city engineer to create a plat for the town. When it was registered with the secretary of the interior, pieces of land were given up for the greater good, and Guthrie was finally an official town.

Beyond legal organization, the scarcity of practical supplies was another matter. In the first days after the Run, food was a prized commodity, and a man cooking bacon nearly sparked a riot when people came asking for a bite. Entrepreneurs took advantage of the situation, such as the owner of the "Elite Café," where a woman sold cold meals out of her wagon at $5.00 apiece ($130.00 in 2015). Others walked among the claims, selling water from the creek for $0.06 a cup ($1.50). Using the toilet at a private latrine cost a dime ($2.59).

As supplies poured into the town, Guthrie blossomed. A record 480 carloads of lumber (worth more than $3 million today) arrived in a month, and anyone who could swing a hammer found work as a carpenter. Urged on by city boosters like Frank Greer, brick buildings soon replaced the wooden ones, and civil government paved streets. Much of the early work was done by taxation; each man between the ages of twenty-one and fifty had to donate four days of conscripted labor per year, starting in 1894.

The community effort and capital investment proved to be a boon to the city. Civic works had supplied running water by summer, replaced by larger

Progressive Guthrians established a waterworks within years of settlement.

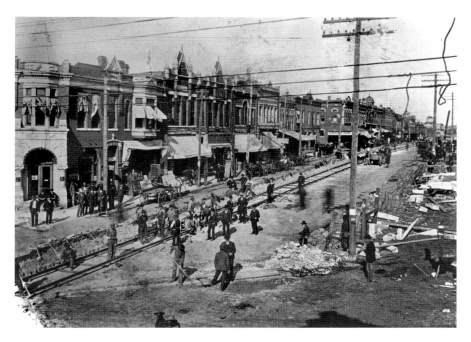

Workers lay trolley tracks down Harrison Avenue. *Courtesy Bob Bozarth Photography.*

facilities to the south in 1893. A power plant was put up, and Westinghouse electric lights lit the streets by September 1889. Bridges, fire departments and nine newspapers showed progress in the town. By 1905, a public trolley ran through Guthrie and connected it to Oklahoma City, Norman and El Reno. Guthrie even featured a two-story privy, a brick outhouse that hosted a wooden walkway from the back of the Triumph building put up in 1899. Thanks to the cleverness of landlord Winfield S. Smith and Nathanial McKay, tenants had two floors of two privy seats each, meaning fewer stairs for answering nature's call.

Even as Guthrie became settled, there was an air of spookiness to it. A few days after the Run, the wind picked up. First it brought in dust, then sand and finally a storm that demolished most of the scant buildings that had been built. Tents were torn up, and any unsecured property blew away. Driving rain doused the town for four days. Soldiers who had served in prairie forts for years said that it was the worst they had ever seen.

Many took the storm as an ill omen. Rumors of wicked luck flew through the settlements. Some people packed up, forgetting any dreams of finding a

new home and going "back to the States," as the longer-settled areas of the United States outside the territory were called. Unsettled Oklahoma must have seemed like a foreign world riddled with plagues. City lots that were worth hundreds sold for as little as five dollars during the exodus.

Soon the weather turned fair again, and later those who stayed soon wished for rain. A failed crop in 1889 led to many more settlers heading back to the States. Congress sent $47,000 in emergency aid, but that would be only temporary relief. The railroads, seeing their potential customers packing up, made efforts of their own. The Santa Fe lent out $10,000 in seed, to be repaid upon the next successful harvest. The Rock Island Railroad followed suit with $10,000 of its own.

After a rough start, Oklahoma took off. The agricultural base laid a foundation for commerce, and business surged in Guthrie. The 1909 *Oklahoma Annual Almanac* records Guthrie as having forty-seven industrial plants employing more than 2,500 people, a "cotton mill, three cottonseed oil mills, a box factory, a furniture factory, three candy factories, four cigar factories, two ice plants, three ice cream factories, the iron factory, two flour mills, a cereal factory, three corn mills, one stone factory, one boiler factory, a gas factory, a shoe factory" and still more.

As Oklahoma proved to be a profitable enterprise, Guthrie worked to civilize itself. The city hosted numerous opera houses and, in 1913, an indoor swimming pool at the Mineral Wells Bathhouse. Even before that, spacious Island Park was established south of the Elbow with boating, a horse racing oval and picnic lawns. Mineral Wells Park, as it came to be known, served as the site of the first Bedlam match between the University of Oklahoma (OU) and Oklahoma A&M, which would become OSU. Today a marker stands nearby the site of the game, which took place on November 5, 1904. On a day of bitterly cold wind that flung ice in the faces of the players, the first touchdown came as a wild punt that sailed overhead and into Cottonwood Creek. Both teams charged into the water after it with OU at last seizing control and running it back onto the field to score. OU's Rough Riders beat A&M's Tigers 75–0.

Guthrie warranted its own Carnegie Library in 1901. Although it was a fraction of the donation Oklahoma City had received from Andrew Carnegie for its library in 1899, Guthrie treasured the building. It was on the steps of that library, as thousands gathered to watch from the streets, that a mock-wedding was held between a cowboy and an Indian maiden to show the joining of Oklahoma and Indian Territories into a new state on November 16, 1907.

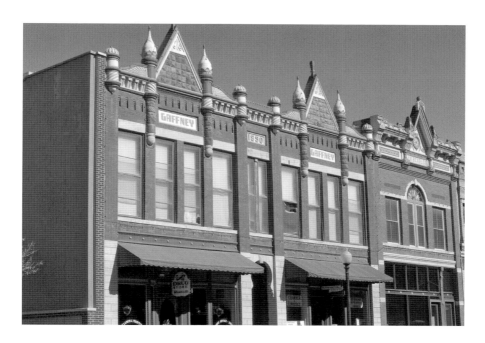

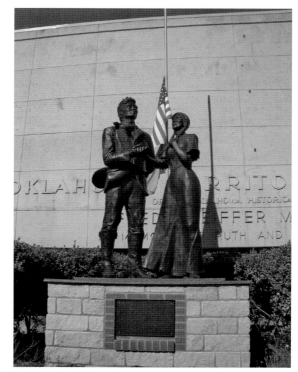

Above: The iconic Guthrie downtown is a sprawling National Historic Area.

Right: A statue commemorates the ceremonial marriage of Mr. Oklahoma Territory and Miss Indian Territory.

Guthrie stood proudly as the first capital, but the honeymoon didn't last long. Just two years after statehood, Guthrie was dealt a brutal blow. The businessmen of Oklahoma City conspired with Governor Charles N. Haskell to achieve a goal they had pursued since the Land Run: to become the new capital. Although the towns were neck-and-neck for size and clout in 1900 with about 10,000 citizens apiece, Oklahoma City's population had surged more than six times to 64,205, according to the 1910 census. Guthrie, meanwhile, had a respectable growth of 16 percent. With a bigger economic base, Oklahoma City managed to win more and more support, especially as the largely Democratic state of Sequoyah was chosen by Congress to be joined with the less populous Republican Oklahoma Territory in the Enabling Act of 1906.

Businesses soon followed the politicians as Oklahoma City offered a larger workforce and better railroad connections. Although it still had its many boosters and deeply rooted connections with organizations like the Masons, Guthrie began to fall into a slumber. Buildings were vacated, and population growth stymied.

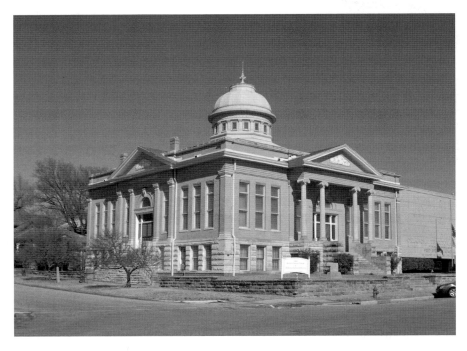

Statehood was declared on the steps of Guthrie's Carnegie Library in 1907.

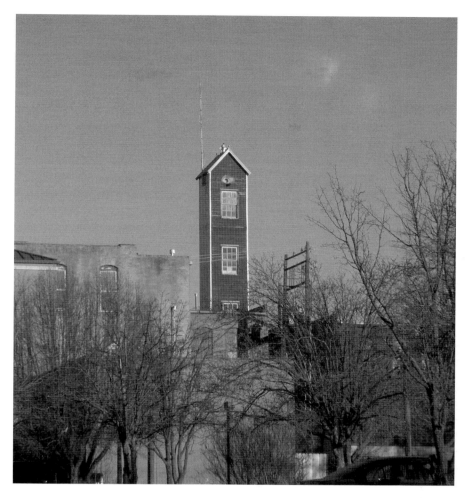

Guthrie has one of the few remaining firehouse towers, where hoses were hung to dry.

Sixty years after losing the capital, Guthrie underwent a renaissance. In the 1970s, Oklahomans seemed to wake up to the history of their state as the nation prepared for the bicentennial. Guthrie was by then ahead of the pack, awakened by the bang of the demolition of its old city hall in 1955.

Like many of Guthrie's buildings, the native brick city hall was designed by Joseph Pierre Foucart, a Belgian architect who came from Paris to contribute to the new city. He was paid $25,000 in 1900 to design the hall, which was iconic with its parapet-laced tower and wide wings. City hall opened in 1902, and by 1955, it was seen as part of the broken past.

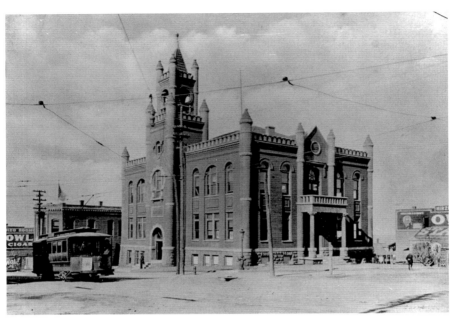

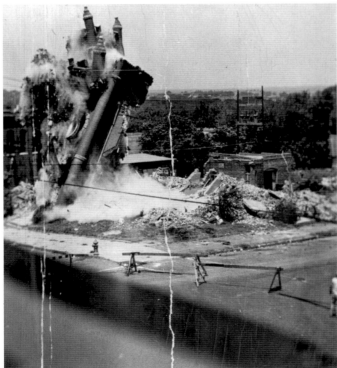

Above: The original Guthrie City Hall, designed by Foucart. *Courtesy Bob Bozarth Photography.*

Left: The final demolition of city hall with the collapsing of its tower sent waves through Guthrie. *Courtesy Bob Bozarth Photography.*

Many felt otherwise, citing the significance of the building as the site of the state constitutional convention, but their cries were not heard until after the building was imploded.

Guthrians said, "Never again!" They launched campaigns urging fellow Oklahomans to treasure their history. The call was heard, and in 1972, the Oklahoma Historical Society opened the Territorial Museum in a large building attached to Guthrie's original Carnegie Hall. Two years later, the Guthrie Historic District was placed on the National Register of Historic Places, protecting block after block of original Victorian façades. Because of these efforts, Guthrie has become a destination for tourists looking for a taste of the Sooner spirit of old.

In addition to antique seekers and romantics looking to bask in bygone times, Guthrie also hosts many visitors curious about the strange and supernatural events that seem to resonate through the city. The spirits of shopkeepers and residents seem to remain behind even after their bodies pass away. Throughout the town, everyone has a story of hearing footsteps despite being alone, feeling the sensation of being watched by unseen eyes or actually witnessing the touch or presence of a spirit. Some have ventured to call Guthrie's downtown one of the densest populations of ghosts in the United States.

The stories collected here barely skim the surface of Guthrie's lingering past.

CHAPTER 1

SCREAMS FROM THE SHACK

THE STORY OF ELLA MYERS

Along with the need of services for the living like electric lighting and running water, there is also the problem of what to do with those who had died. Life on the prairie was rough, and folks passed away from illness, age and the occasional gunfight. In the country, graves were wherever someone saw fit to bury a fallen relative, but townsfolk needed to be more organized.

An initial cemetery was established on a plat in space shared with the soon-to-be-built school. This must have made youngsters nervous, but they gained some respite when the new cemetery was soon found to be too small and bodies were moved far outside of town to the north, the site of today's Summit View Cemetery.

Yet Frank Greer noted in the *Oklahoma State Capital* in 1889 and again in 1905 that not all of the graves were found. In the early days of Guthrie, few had access to fancy headstones, so most of the grave sites were marked with humble wooden crosses or a flat rock. It would take only a windstorm or two to fell the crosses and cover up the rocks. As workers transported bodies, anyone would agree that they missed a few. Rumors of bodies under the school have spawned any number of urban legends about haunts in the halls through the years.

Guthrie's earliest ghost story, and one of its most gripping, comes from a satellite cemetery established on the west side of town. Unlike the larger municipal cemetery on the hilltop, this was near the creek, an area that an

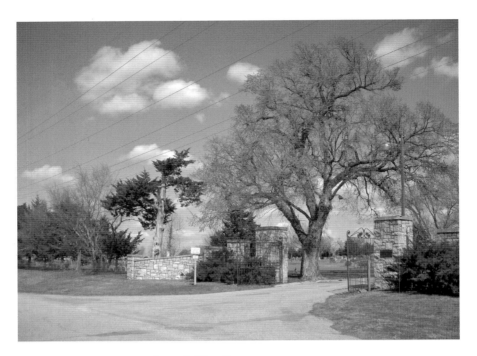

The welcoming entrance to Summit View Cemetery.

editorial in the *Guthrie Daily Leader* called "a marsh on the Cottonwood." Poor folks who could not afford a serious funeral, and those who did not even have the notoriety to be interred at "Boot Hill" at Summit View, found a budget resting place there. One patron, it seemed, did not take the mistreatment lying down.

In the April 8, 1896 edition of the *Guthrie Daily Leader*, in the "City in Brief" columns between reports of which town notable was traveling to Chandler and who was returning from Fort Worth, there is a humble three-line obituary: "Ella Myers, inmate of Ella Huston's place on the Santa Fe right of way, was found dead in bed Sunday morning. Her death was due to an overdose of cocaine."

Legend fills in the gaps of the story. Ella Myers was a prostitute in the employ of Ella Huston, who owned a shack with a few rooms on the west side of town near the Santa Fe railroad. Locals and those stopping by on the train knew it to be a place for a cheap thrill. Like many madams, Ella Huston kept girls in their line of work through various means of control. According to rumor, young Ella Myers was addicted to cocaine, which, although quite

legal in 1896, was a very expensive habit. Few would have seen the overdose as much more than a pitiable tragedy.

Across the columns of the *Leader*, however, a report digs deeper into the issue by posing the question, "Was She Buried Alive?" The article refers to Ella Myers the "cyprian" (the Victorian way of avoiding the word "prostitute" in polite print), who died a "strange and sudden death." Some say that a quick autopsy by the city coroner proved the cocaine overdose, but the article maintained, "No one knows positively what caused the woman's death and no inquest was held over the remains." Instead, "within a few hours after the woman's supposed death, the body was thrown into a box." She was then buried in the pauper's cemetery, not far from the railroad crossing.

Despite the assurances from Commissioner Stapleton that the girl was clearly dead and the hastiness was only in the best interest of civic health, the *Leader* argued, "Two reputable physicians asserted yesterday that the girl was buried alive." It stated, "A speedy investigation is needed here," but the cry fell on deaf ears.

The mystery of the actual events of the fateful night of Miss Myers's passing only grew. Ella Huston quickly left the house and locked it up. She disappears from the newspaper's narrative, along with James Whitman, "the man who was with the Myers girl the night she is supposed to have died [who] has not been seen since the burial." Whispers around town suggested foul play, and some even believed Whitman was the scapegoat for a more prominent official.

Even though the shack stood empty, strange things began to happen there. At night, the sound of wailing came, sometimes softly, sometimes so loudly that it could be heard down the block. The *Leader* says some "twenty-five to thirty persons" came out of curiosity to see what was making such noise. Various phantoms, disembodied howls and even floating objects infested the shack. One of the few named visitors, Kickapoo Charley, looked in on the night of Thursday, April 16 and "saw an apparition." The shock proved so much he fainted. Days later in the paper, it noted he "has been ill ever since."

One Guthrian, man-about-town George Hardie, was skeptical about the whole thing. He determined that the story was "a supreme josh" and meant to find out how the pranksters were pulling their joke. On Friday, April 17, he approached the house at night during the prime time for activity, planning to catch someone in the act of noise-making.

According to the *Guthrie Daily Leader*, Hardie "found the front door locked. Going to the back door, it was found locked and bolted." He went back

around to the front door, tried to open it again and soon gave up. The house was secured, just as everyone had said.

Hardie had just turned away when suddenly a mournful wail began. It tore through the quiet night and "assailed his ears." What had been a lonely, locked shack had suddenly filled with eerie activity.

A moment after the moan sounded, the front door "slowly swung open."

This was a point where most men would have turned in the investigation and congratulated pranksters from afar, but Hardie was resilient, "although badly rattled," according to the *Leader*. He crept into the house and explored until he came to Ella's room, where the bed she had died in still sat.

There, out of the darkness, something hit him with "four sharp raps on the head." Recoiling, Hardie couldn't find anyone standing beside him. The darkness gave way to a bright light, "resembling a calcium ray," that flashed across the ceiling. Out of it, a "blood-red hand clutching a bottle" descended into the room. The vision and the attack were ample evidence for Hardie to give up his belief in pranksters. He rushed out of the shack and humbly confessed his entire experience to the newspaper.

The supernatural noise only grew as the week wore on. The *Leader* noted that many of the "shacks in the vicinity of the haunted dwelling have been vacated." Other neighbors, however, had nowhere to go, and so they stayed and witnessed the howling shack grow louder and more terrifying night by night.

By April 19, the story was front-page material: "The ghost of Ella Myers continues to walk with uncanny tread at the erstwhile dive at the Santa Fe right-of-way." The article details a frightening picture. At midnight on April 18, the two doors of the little shack burst open, all at once and without any sign of human hands. Neighbors startled by the noise went to investigate, finding "a figure, clad in white" at the windows. Although she was seen as a ghostly woman, the spectators could describe little more than her standing. The sounds that accompanied the strange appearance, however, were vivid.

Groans rattled the night, just as they had for more than a week. Among the howling noise this time, a "plaintive wail" called out the same clear words, "Don't give me any morphine. I am sick."

The ghostly line came three times that night, and everyone agreed about what was said. Were these the final words of a poor addict? Some thought that it was a last-ditch effort to use the opiate to prevent Ella's death from cocaine overdose. Others nodded along with more sinister rumors that the

morphine was the actual cause of death and someone gave it to her as part of covering up his or her misdeeds.

With such ghostly turmoil plaguing the town, citizens began demanding answers. Something was keeping Ella Myers from resting in peace, and the strongest voice of opinion turned on the burial practices at the cemetery. The *Leader* itself asked, "Is her body buried upside-down?" Such an indecent burial would surely cause a spirit to roam. More and more residents insisted that opening the hurriedly buried body would reveal the truth.

Guthrie police, however, were uneasy about opening the grave. They worried that whoever opened the coffin would find the body "distorted and twisted," following the belief that she was, perhaps, buried alive. They also voiced concern that the African American grave keeper and her family who operated the cemetery would become personally haunted by the increasingly violent ghost.

The matter was finally settled when Ella's half brother, H.M. Myers, arrived from Kansas. He had learned of Ella's death through the *Leader*'s interstate reprints and arrived on the train to her rescue. As next of kin, he was allowed to exhume the body on April 23. Nerves throughout the town were settled when the box was found without any telltale scratch marks of live burial. Myers took her out of the town and had her reburied in Mulhall Cemetery.

The shack went quiet. Ella seemed pacified now that her body had been taken out of the pauper's cemetery. Many Guthrians took that as the source of Ella's stirring: the grave was simply unfit for her. A *Leader* editorial agreed, "A man who would place a dead body in that soggy plat of ground is devoid of all the merciful, humane feelings which go to make up a man…About twice a year the river rises and overflows the graves—and we drink the water."

Yet the *Leader* posed a different suggestion: "The girl was not only buried alive…in the rough box face downward, but since the recent comment regarding her burial, interested parties secretly disinterred the remains and placed them in their natural position." The spirit came to rest because whatever wrongs had been done to the body were righted, even if those who did it were quiet about it. Perhaps a little decent treatment was all that Ella wanted.

CHAPTER 2
A THING OF FLESH AND BLOOD

STATE CAPITAL COMPANY BUILDING

The Foucart-designed three-story brick building at the corner of Harrison Avenue and Second Street is often confused by visitors to Guthrie for the old state capitol, namely because it has "Oklahoma State Capital" printed all over it in big letters. Rather than serving the early state legislature, it was actually the office for, in many ways, the legislature's arch-nemesis, Frank Greer, editor of the *Oklahoma State Capital* newspaper.

Greer was born in Leavenworth, Kansas, in 1862, the youngest son of a Union army captain. His father died when Frank was young, and the Greer boys left home to work. Frank began as a delivery boy at his brother Edwin's newspaper, the *Winfield Courier*. Young Greer climbed through the ranks at a dizzying pace to reporter and then to managing editor. He was infamous for writing more copy in his articles than there was space on the page and constantly had to be roped in.

Frank had bought an interest in the paper, but as the opening of the Unassigned Lands approached, he had aspirations of starting his own. With Edwin's blessing, he sold his interest back and prepared to cover a whole new territory with the *Oklahoma Capital*. The paper launched in April 1889, even before the land was opened. It proved a cunning business measure, since it was passed out to many of the people preparing to make the Run and gave them a tip on whom to hire for their news.

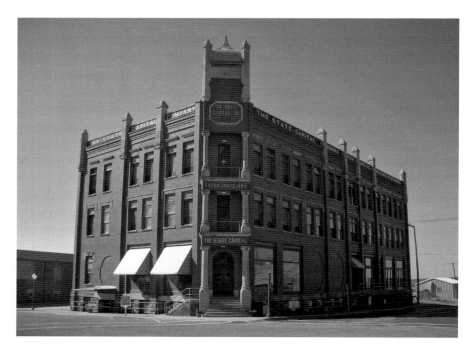

The center of Greer's *State Capital* publishing house.

Using the name "*Capital*" was perhaps ostentatious, especially since Oklahoma was not yet even a formal district, much less a territory in need of a capital. Yet Greer was a man of unbounded vision, and he would not let a simple thing like the nonexistence of a town keep him from publishing a paper for it. The first issues of the *Oklahoma Capital* came off borrowed machines in Winfield while newly married, twenty-seven-year-old Greer went to cover the Land Run firsthand.

Like many settlers in Guthrie, Greer rode the train into the Unassigned Lands. Unlike most of them, Greer came a little earlier than the noon gunshot. According to his letters written much after the fact, Greer and a pal stowed away on a freight train passing through the empty lands, which were under patrol by soldiers to ensure no Sooner sneaked in under the moonlight and received an unfair advantage. When the train arrived in Guthrie, the pair jumped out and ran into the woods down in Cottonwood Creek. They camped out and hid there until 12:10 p.m. the next day, as the trains for the Run were arriving. Greer then crossed town and staked a claim of his own toward the east.

There has been plenty of argument about whether Greer himself was a Sooner, a term he used often with grating disgust in his editorials, targeting citizens of Oklahoma City and Kingfisher. Greer defended his actions as wanting to get to the scene of the land before the Run, which could make for comparative journalism. There were plenty of people quick to exploit any potential fault in Greer's career, just as there was a legion of Guthrians who eagerly followed his every energetic word in his articles.

After the Run had settled, Greer printed his first hometown edition on May 12 out of a tent. He later moved into a wooden building, which prompted him to expand his run with a second-hand press. While he was walking the streets awaiting the press to arrive by train, Greer came across O.H. Richards, who had served with him in Winfield as circulation editor. The meeting was a shocking coincidence, and Greer offered Richards a position on the spot. Richards's first job at the newspaper was helping to unload and assemble the new press.

Richards proved to be a talented ally. In a city without streets, much less addresses, he devised a method of ensuring people received their papers. Each subscription came with a six- by six-inch card with a stark "C" standing out on it. Settlers could hang their cards on a pole or pin them to their tents; whatever worked as long as they were visible to the boys running to make their deliveries.

While Guthrie would always remain at the center of Greer's heart, he also sought to expand his business. He recalled in his letters, "Arthur Locke and I took a trip to Oklahoma City three days [after the Run] with about 200 copies of the paper. Its name led the people of that town to think that the *State Capital* had been printed in Oklahoma City. At that time no paper had been printed there."

Just as Guthrie appeared overnight, so did a half dozen other papers. In November 1889, just seven months after the Run, Edna Swartout wrote, "We have four daily and five weekly papers here now. Some newspapers are competing for news." Greer quickly gobbled up his earliest rival, the original hometown paper in Guthrie, the *Guthrie Get Up*, first published April 27, 1889. Then came more dailies competing with the *Capital*, including the *News*, the *Herald* and the *Optic*. Greer's powerful editorial stance and charisma throughout the town kept his paper on top, not to mention the flow of national and international news from his brother's paper arriving "print-ready."

There was one nut that Greer found impossible to crack: the *Guthrie Daily Leader*, which took up the minority status in Guthrie as the Democratic voice

to Greer's booming Republican one. Judge Frank Dale founded the *Leader* in 1892 specifically as a rival to Greer. What Greer criticized, the *Leader* championed and vice-versa. In 1894, the paper moved into its offices at 107 West Harrison, where it still resides more than 120 years later as the *Guthrie News Leader*. It gained a great boon when it won the bid to print seventy thousand copies of the proposed state constitution, which also satisfied the mostly Democrat legislature in depriving revenue from Greer, who had served as the territory's official printer since 1895.

As much of an enemy as he was to Democrats, Greer was a friend to Guthrie. He estimated that Guthrie would have a population of seventy-five thousand by 1891, although slow investment proved otherwise. Still, Greer's editorials continually egged on the city council to find funds for projects he thought would be a boon for the town. He called for bridges to be built first across Cottonwood Creek, then the Cimarron and even up to Skeleton Creek. Every new business in town was lauded, and his words shouted on the page for civic improvements like trolley service and gaslights. He routinely encouraged Guthrians to buy into city bonds for new structures to cement

Guthrie trolleys (now buses) still run on historical routes.

the town as the permanent capital, such as Convention Hall in 1908.

Up to that point, territorial and state offices were held in borrowed space from the Logan County Courthouse. Again and again, bills had been proposed for state funding for a capitol building, and again and again they were voted down for various reasons, all disguising that the Democratic legislature didn't want to face constant battles just a few blocks down from Greer's Republican press. The first state governor, Charles N. Haskell, referred to Guthrie as a "nest of Republicans." After statehood, the feud became so bitter that a special committee of mixed Republicans and Democrats approached Greer in 1908 to plead with him to find a way to make peace. It did not make progress.

The political arguments went alongside Oklahoma City's growing ambitions to

move the capital to the burgeoning city to the south. Within a few years of the Run, Oklahoma City had outpaced Guthrie in population and industry, but Greer and his progressive, pragmatic Republicans rested easy in the Enabling Act of 1906, which mandated that the capital would stay in town until at least 1913.

Just as Oklahoma City continued to make advances on becoming a capital, it also once tried to seduce Greer, after the famous fire that wiped out the *State Capital* print shop after the turn of the century. Joseph B. Thoburn wrote in his 1936 remembrance of Greer, "There came a Sabbath day, nearly a dozen years after the beginning, when the *State Capital* plant all went up in flames and smoke, with a money loss of nearly $200,000 and only $26,000 of insurance. The people of Guthrie promptly raised a subscription of $50,000 for him to use in his own business, as long as he might want it, but he declined to accept it in any form other than as personal loans to be paid back with interest.

Thoburn added, "Moreover, the business men [*sic*] of Oklahoma City sent a committee to wait on him and offer to duplicate the destroyed plant if he would install and operate it in Oklahoma City, but his loyalty to the community which he had helped found and build, and whose people had always been his neighbors and friends, was such that he could not consider such a change, so he declined the Oklahoma City offer and cast his lot anew with Guthrie. And Guthrie's interests were his interests, regardless of personal inclinations, preferences or predilections."

Even though Greer vowed to stay with Guthrie, the state government did not. In March 1910, Haskell signed the bill for a special election on June 11 that would determine the capital enduringly. The three towns contesting were Guthrie, Oklahoma City and Shawnee, a ringer (Greer said) meant to divide the Republican vote for Guthrie. The neutral *Tulsa World* called it a "raid on the State treasury in the interest of a single town." Other papers agreed that such a move would just cost taxpayers money. Yet, when the votes came in, Oklahoma City won with 96,261 votes, with Guthrie and Shawnee trailing at 31,301 and 8,382, respectively.

The bill never mentioned when the move would take place, but Haskell had the notion that, since the citizens had voted, Oklahoma City would be the capital immediately. He stayed in Tulsa to give a sense of security and, after midnight, when the polls had closed, called his secretary, W.B. Anthony, to "steal" the seal.

The legend of the theft of the Great State Seal of Oklahoma takes many forms. Some describe efforts by Anthony sneaking in back windows. Others

state that Haskell performed the theft personally. There are even versions where physical battles went on, including gunfire, as the huge round stone block now in the floor of the capitol building was hoisted into the back of a vehicle with the engine running.

The truth is more mundane, although still a shocking bit of subterfuge. The actual state seal was a stamp that fit in Anthony's pocket. A car supplied by the Oklahoma City Chamber of Commerce picked up Anthony, and he went along with two of the governor's office clerks, including Earl Keys. The clerks told the guards that Anthony had left a bundle of laundry in the office (which he had), and they smuggled the seal and the state recording book out in the laundry. According to Keys, Anthony even typed up a receipt and left it in the office. They then drove down to Oklahoma City, as Anthony later recalled, "in what was altogether a very uneventful trip."

Governor Haskell met the bandits at the Lee-Huckins Hotel and prepared for a celebratory breakfast. Anthony described, "I said, 'Just a minute.' I stepped up to the clerk's desk in the hotel, got a sheet of paper—the hotel letterhead—a pen and ink, and wrote the official proclamation…'Oklahoma City is the capital of the State of Oklahoma.'" Then he stamped it with the seal, and it was official.

In Guthrie, headlines boldly stated, "CAPITAL OF THE STATE RAVISHED BY BRIGANDS FROM THE SOUTH." Led by W.H. Coyle, Guthrians sued to get the capital back. The fight went all the way up to the United States Supreme Court, where *Coyle v. Smith* decided that the Enabling Act was dictated to a territory by the federal government while the election by the state was protected by the Tenth Amendment. Oklahoma City was officially the capital.

Greer's life in Guthrie was coming to an end. His wife, Blanche Byers, had died a few years before, and now he seemed to be losing the other most meaningful part of his life. Almost exactly one year after Haskell's announcement of the vote that cost Guthrie the capital—March 30, 1911—Greer printed his last edition of his newspaper. The front page served as his farewell editorial: "It is hard to part with the *State Capital*. It is my child. To me it has been a thing of flesh and blood…The best years of my life have been devoted to it. Many cherished memories are bound up in it."

After spending twenty-two years in Guthrie, Greer moved to Tulsa, where he left publishing, married widow Laura Leigh Hanson and became a venture capitalist in savings and loans. When the oil boom struck, Greer was in the middle of it with leases to some of the richest oil fields in Oklahoma. Yet his money was all on paper, which meant that it vanished along with the

stock market and bank crashes of the late 1920s as his own health waned. The strain of the Depression proved too much for Greer, and a heart attack took him in 1933.

For many years, the State Capital Company stood as the State Capital Publishing Museum, housing dozens of original typewriters, linotypes, printing presses and bookbinders from all over the early state. Rumors swirl that, at night, the machines come to life, just as when they were in use by busy newspapermen setting into print. Paranormal investigators speak of "residual" spirits, emotional imprints left behind to reenact powerful moments in the life of someone who has passed on. The energy and passion of men laboring over presses might imbue the iron and wood so deeply that they are willing to carry on the work themselves.

Some whisperers go as far as to say these are the ghost of the newspapermen themselves, and none more so than Frank Greer. It is not hard to imagine that someone so fervent would return to Guthrie from his grave in Tulsa. Besides, if Greer could print a newspaper entitled "*Capital*" for a city that wouldn't be a capital for more than a year, would a little thing like death keep him from his work?

CHAPTER 3
ABANDONED

THE ELBOW

While officially dubbed "Noble Park," the island in the midst of Cottonwood Creek as Snake Creek branches away and doubles back into it is best known as "the Elbow" for the way the land sticks out from western Guthrie. It is a treacherous floodplain that has been lambasted with overflows time and again, yet for much of Guthrie's history, it served as home to one of the state's first African American communities.

The earliest modern "settlement" of the Elbow was the pitched tents of the soldiers from Fort Reno, who had been brought in to patrol for Sooners in the days leading up to the Land Run of 1889. They were commanded by Captain Arthur MacArthur Jr. Because the soldiers were given orders to maintain the peace as long as deemed necessary, their stay was indefinite, and so MacArthur brought along his wife and two sons, Arthur III and Douglas. Nine-year-old Douglas MacArthur later wrote of fond memories swimming in Cottonwood Creek in the summer after the Run. By July, the district had settled enough that the soldiers marched back to Fort Reno, and MacArthur was promoted to Washington. His son Douglas went on to military school, after which he would sign on and serve as supreme commander for the Pacific theater in World War II and then supreme commander for the Allied Powers as war in Korea began.

The African American community came to the area in a twist of fate. The Oklahoma District had long been seen as a place of hope as the Civil War

ended slavery but left a good deal of discrimination yet to be resolved. In his dissertation study of race in Oklahoma Territory, Arthur Lincoln Tolson wrote, "Choctaw and Chickasaw leaders appealed to the United States Secretary of the Interior and Congress in the 1870's that their former slaves be settled there, but no action was taken." A national appeal was created through the Freedmen's Oklahoma Immigration Association in 1881, but even with tens of thousands of signatures on petitions and a bill introduced by New Hampshire senator Henry Blair, Congress ultimately determined to delay settlement until the opening in 1889.

In 1890, a year to the day after the Land Run, Edward P. McCabe and Charles Robbins founded a new township named Langston after African American congressman John Mercer Langston. McCabe was a black man who knew firsthand the hardships of segregation in the South. Robbins was a white landowner who had bigger ideas for his claim than simple farming. The two shared a dream that became a triumphant reality when they invited African Americans from across the nation to come settle in a community that would be free of racist tyranny. Langston, and other towns like it, soon flourished on the prairie. Within a few years, Langston touted dozens of businesses, a bank, a newspaper and, soon, the Oklahoma Colored Agricultural and Normal College, which would become Langston University.

As the center of the new land, Guthrie drew many African American settlers. Many of those chose to move on to black towns like Langston, Liberty City and Liberty, but some were stuck in the city without money to travel. Walking the last thirteen miles would be a full day of hard work, and the elderly or sick wouldn't be able to make it at all. Often relatives would go find work and send money back; until then, a community of African Americans set up camp along the railroad tracks to wait for dawn.

Everything suddenly changed when the fledgling territorial court rejected a land claim on the southwest edge of Guthrie. A man named Bockfinger had claimed the floodplain as a large rural plot, while others argued that it should be broken up as part of town. Now, two years later, the court finally made its decision late in the day that the land was part of Guthrie, which meant there were suddenly hundreds of unclaimed plots.

The disparity of the African Americans now gave them something of an edge. Not only were they the closest community to the land, but they were also willing to make a miniature land run in the middle of the night. White settlers who arrived the next morning found every claim already scooped up.

"Little Africa," as the Elbow neighborhood became nicknamed, was a center of black culture. Shortly after its settlement in 1892, a lodge was founded there by the Prince Hall Masons to boost the community. Businesses, many of them eateries, were established along Second Street, just up the road from the Reaves Brothers Casino and the Blue Belle Saloon. Others started their own cottage industries, such as a low-cost graveyard.

The African American community grew, and so did its clout. Territorial leaders began holding conventions to draft a state constitution, and oppressive whites wanted to formalize Jim Crow laws in the new state to maintain what they perceived as balance. President Theodore Roosevelt, however, refused any such constitution that incorporated segregation, saying that his thoughts on the first draft "were not fit to print." The convention members resigned themselves to agree, but when the new state legislature met in 1907, their first act was to institute segregation.

Statehood became a setback for African American rights, which had enjoyed comparable freedoms and a strong cultural base. Yet the community did not quit. In Guthrie in 1908, the first black library in the state, the Excelsior Library, was founded on donations and hard work. By 1910, it had become part of Guthrie formal civic education. Guthrie also hosted Claver College, the first Catholic black institute of higher education in the state. Segregation in Faver High School had become informal by the 1940s; students who wanted to go to Guthrie High School were tacitly welcome even though it was illegal in Oklahoma to educate black and white students in the same room. The football stadium was even shared between the Guthrie Bluejays and the Faver Pirates, who practiced on Thursday nights. In 1951, Faver became state champions in an undefeated season while the white players watched and cheered them on.

Prentiss Hall was a senior on the '51 team who grew up on the Elbow. Segregation was seen as part of everyday life, the same as the regular flooding of Cottonwood Creek. He recalled, "When the water was coming up, when there was going to be a flood, you had to come out and move to high ground."

With every flood over the years, the population of the Elbow declined. People left as they could, seeking more permanent living elsewhere. As the neighborhood depopulated, services became less abundant. One after the other, bridges broke down and simply were not replaced. Those who chose to stay after the floods were gradually detached from town. Soon the land value in the area approached zero, and the City of Guthrie condemned the whole floodplain in the 1970s.

Despite its end as a populated site, the Elbow has continued to be a place of fascination in Guthrie. Before the last bridge gave out in the 1980s, Guthrians rolled through the Elbow to collect items left behind. Many of the artifacts were ruined by the floods, but explorers hoped to find a unique treasure. They dragged away furniture and pulled antique woodwork off walls. Yet much still remained—including, some say, a few residents long gone.

Ghost stories at the Elbow go back decades, to just years after Ella Myers was laid to rest in the graveyard there. One of the most famous is of a mail airplane that crashed nearby in the 1920s. In those days, airmail was specially marked and an expensive, speedy delivery as plucky pilots navigated by landmarks alone; there was no radar and only short-distance radio to spotters who could help them. The biggest boon came with beacon towers built on concrete foundations shaped like huge arrows. These markers helped light the night and also showed directions so pilots could keep their bearings. The program was disbanded in the 1930s and the towers collected for scrap metal, but one of the hundreds of concrete arrows that survived rests near Mulhall.

Unfortunately, the towers offered no help in case of engine failure. This plane ran into trouble and did not complete its route. To this day, people hanging around the Elbow at night or even during the daytime claim to hear the sputtering, troubled engine of a plane just overhead. Such a sound of danger sends people to hurry to look, but no one ever sees the falling aircraft.

Others who have come to the Elbow have witnessed strange visions. Countless people have stories of seeing someone just on the edge of view and then turning to find no one there. Often the phantom is said to be an old man; others say they saw a little girl. The apparitions are not always human, either. One man described how he saw a strange, isolated patch of fog move toward him. He decided to get away from it, and the fog continued to follow him no matter where he turned until he finally fled the island.

Strange rumors about the Elbow are certainly nothing new. During the distrustful days of segregation, many white Guthrians feared the supposed goings-on in Little Africa, including voodoo. These accusations spiked in 1918, when the practice of voodoo did actually increase in the United States. With America joining the World War, men of both races were nervous about being called to the draft. The use of rabbit feet as good luck charms doubled in just four years. In Dallas, the problem became so widespread that a man was arrested for "conspiring with others to evade the draft" by selling lodestones. Two of the magnetic rocks came paired in a blue velvet sack. A

man avoiding the draft would wear one and keep the other under his pillow; the magical "connection" kept him at home instead of being shipped to Europe. Charms like these often sold for as much as $25 (nearly $400 today).

Guthrie had its own run-in with a voodoo "conjurer" in 1918, as recorded in the *Oklahoman*. George Grayson set himself up as a witch doctor, preparing spells for those willing to pay. These might often be harmless luck charms, but he was soon an evident predator. William Slaughter, a blind man, paid him thirty-five dollars to remove the "bad spirit" that was causing his blindness. Slaughter did not regain his vision, nor did many others who sought help from Grayson.

Grayson's jig was up after he was given $110 by Ada Magnon. She was caught up in a legal battle over a deed to land in Creek County. The fee must not have seemed like much to guarantee a swift victory, but when it didn't come, she turned on Grayson. After Magnon contacted police, Grayson disappeared, "believed to have started for Oklahoma City." While he proved to be a con man, others superstitiously pointed to it as a case of genuine witchcraft in his escape.

A century later, some are still too superstitious to visit the Elbow, treating it as an open-air tomb. Thrill-seeking hikers, however, explore the Elbow, even though Noble Park has no official entrance. A clever few have marked trails where a curious trekker can hop the creek and climb up to explore. Satellite images still show vague traces of roads among the trees, but nature has reclaimed much of the land. Nathan Turner, director of the Territorial Museum and Historic Carnegie Library, led something of an expedition there in 2001, describing a few structures still standing, such as a swing set in the park and the ruins of the community church.

Years later, people say that it is woods where hikers wouldn't see a building until they practically came up to it. Untold relics from the past still haunt the Noble Park forest, resting low over the creek that serves as its forbidding moat.

CHAPTER 4
THE GIRLS UPSTAIRS

BLUE BELLE SALOON

The two-story brick building at 224 West Harrison, the corner of Second Street across from the State Capital building, is not the original Blue Belle Saloon. That one, a wood-frame structure, burned to the ground in 1893. The Blue Belle was rebuilt in 1899, a testament that Guthrie's oldest eating institution would never really die.

The Blue Belle wasn't the first saloon in town, but it came as a close second. Moses Weinberger moved his entire operation from Kansas following the Run, dubbing it the "Same Old Moses Good Times Saloon." The lengthy title stood on the storefront across Harrison from where the Blue Belle would soon set up shop. Weinberger's liquor license came from Kansas, and since it was the same saloon, it was believed the license could hold up. With Oklahoma District's strange legal position, no one was quite sure what to argue.

By law, no liquor was allowed in Indian Territory, of which the young Oklahoma District was vaguely legally a part. This did not stop settlers from wetting their whistles with hard cider and "hop tea," which wiggled around the seemingly firm liquor laws. In May 1890, the Organic Act allowed booze into the new Oklahoma Territory, and the saloons were soon in full swing. The wildness brought the territory to the special attention of prohibitionist Carrie Nation, who visited Guthrie three times in 1902,

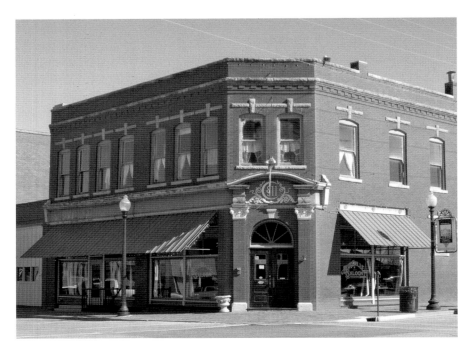

The Blue Belle welcomes guests as it did over one hundred years ago.

1904 and 1905. Nearly one thousand people attended her speech at the Salvation Army Barracks, and it is said that she took her famous hatchet to the Blue Belle itself.

Throughout the years, the ownership of the Blue Belle Saloon has passed through many hands. Despite the change of ownership, its historic fixtures have remained much the same. When guests first approach the Blue Belle, they are greeted by the same historic doors that have hung in the doorway for more than a century. Just above the doors rests a small, stained-glass Lunette window with a large letter *C* encircled by a double *S* figure and a double *L*.

The interior of the building continues to house the original clay tiles on the floor, though some are chipped and cracked due to the wear and tear of time. The pressed tin tiles on the ceiling show a bullet hole, authentic to the rough-and-tumble days of early Guthrie. Original woodwork can be seen throughout the building, and the solid wood bar with a time-weathered mirror from over one hundred years ago still invites thirsty folks to the full saloon. Today, the restaurant is considered more family friendly, but it still serves nineteenth-century local dishes like catfish, meatloaf and fried steak.

Bartender, boxer, musician and movie star Tom Mix is a celebrity to this day.

The walls hold various pictures of film stars who have visited Guthrie, such as Dustin Hoffman and Tom Cruise of *Rainman* and Bill Paxton and Helen Hunt of *Twister*, but none is more praised than Tom Mix, who served as bartender at the Blue Belle before becoming a famous silent film actor. Mix came to Guthrie after being discharged from the army, and he soon became a prominent, if somewhat infamous, leader. He learned to ride by borrowing horses from Guthrie's livery stables. As remembered by Guthrian Clifford McCubbin, once Mix mastered the art of riding, he began a career as a bronco buster, "breaking wild horses shipped in from Colorado." McCubbin also recalled he was the "star quarterback on a Guthrie city independent football team." In addition, Mix organized a city boxing league, taught classes in Guthrie Public Library and served as drum major for the local militia band, a position he won as a personal friend of Territorial Governor Thompson Ferguson. Changing positions regularly due to brawling, Mix served as bartender at Ohio Miller's saloon, the Guthrie Bar and at least two bars in Oklahoma City. It was in the Main Street Bar where Tom met Zack Miller, who headhunted him for the 101 Wild West Show. Traveling show business led to movies in California, making Mix an Oklahoma star several years before he was joined by the likes of the more cordial Will Rogers.

An old set of stairs stands farther back into the building, leading down into the basement. The basement houses a large open room and a second bar, rumored to be a speakeasy in the days when Prohibition began. Other rumors say that it has always been filled with gambling tables, giving drinkers entertainment beneath the streets. Legend has it that many government officials of the territory and the young state would sneak into the downstairs area through a series of underground tunnels in hopes of not being seen entering the establishment.

Above the old saloon, the second floor consists of a large open area surrounded by seventeen small rooms, collectively known as "Miss Lizzie's." Throughout the years, it has been said that Miss Lizzie was actually a madam and that the second floor was her bordello. Miss Lizzie's

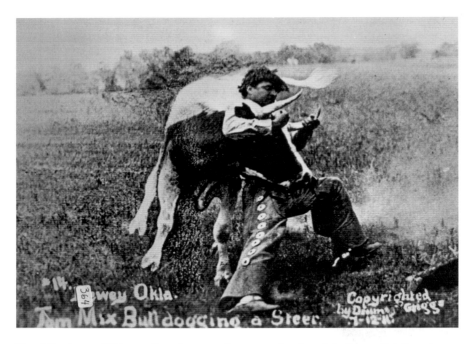

Tom Mix shows off his manliness by wrangling a steer barehanded. *Courtesy Bob Bozarth Photography.*

was a favorite place of many government officials as well as prominent businessmen, who used the same tunnel system and the back stairs to keep a low profile as they came and went. Some of the older photographs of the building show a covered walkway leading from the Elks Hotel that goes straight to the second floor of the Blue Belle, suggesting another entrance to Miss Lizzie's establishment.

One of the best-known legends about Miss Lizzie's is the story of Claudia. Claudia was a teenage girl whose family's farm faced foreclosure in the rough economic years after the Land Run. In order to keep the farm afloat, Miss Lizzie offered a loan, on the condition that Claudia become one of her working girls in the bordello. The life of sex slavery did not agree with her, and Claudia's constant sobbing did not agree with the customers. One man determined to make her shape up, and she was beaten to death. Her body was buried inside the building next to the coal chute, or so the story is told. Several groups of paranormal investigators who have explored the building claim to have captured EVPs of Claudia's voice calling out and crying.

The entrance to Miss Lizzie's still stands behind the Blue Belle Saloon.

In an investigation of a building located diagonally across the alleyway from the Blue Belle, a couple of our investigators crawled out of an underground area, which appeared to be part of the old tunnel system. Once out, our ghost radio said, "Tunnel" followed by "Love affair" and ended in "Buried in the concrete." Perhaps Claudia is still trying to tell her story even from beyond her concrete grave.

Sadly, Claudia was not the only young teenage girl to be sold into prostitution to Miss Lizzie. The legends go that Miss Lizzie developed an extensive business empire of lending, investment and entertaining, all built off her financial success from her working girls. There is another young girl by the name of Estelle B., who was the daughter of a widower farmer named Alonzo. She was only fifteen years old when her father sold her to Miss Lizzie, but the reason is unclear. Once sold, all records of her further existence ceased to exist. It is believed that she, too, died an untimely death at the cruel hands of Miss Lizzie or her guests.

There are a few other spirits that are known to roam the Blue Bell Saloon. Many people have reported seeing a white mist in the shape of a woman wandering throughout the building. Some say it is Miss Lizzie herself, still keeping an eye and a controlling hand on her girls even in the afterlife.

Others tell of a man in different areas of the bar. They describe him as being just shy of six feet tall, in his mid-forties, sporting a handlebar mustache and wearing a brown derby hat. The man just stands, as if waiting for a drink that may never come. Then, in the blink of an eye, he's gone.

Another specter of a man is said to haunt the downstairs bar. He is seen less often than the cowboy on the ground floor, but his antics are more often felt. Beer bottle caps, discarded by patrons just as they have been for over a century, fly off the tabletops and bar at unsuspecting guests. Girls might feel a quick pinch from his greedy hands.

Many more patrons of the Blue Belle tell tales of seeing shadowy figures, feeling cold spots, hearing footsteps when no one living walks and recording disembodied voices. Some believe the Blue Belle is one of Guthrie's most haunted locations, while others say it may just be the suds talking. The owners are tight-lipped about any ghostly activity, preferring to live out the past through historical reenactments and skits involving shootouts.

MISS KATE'S ROOM

ADDISON SUITES

Nestled in the eastern part of Guthrie's historic downtown on eastern Oklahoma Street as one walks toward the Masonic Temple, Addison Suites is a lovely upstairs bed-and-breakfast. It rests above the old Sadler's Cleaners with a private apartment fully furnished, a full kitchen, two bedrooms, two baths and a spacious living room area. It's an ideal place to stay for visitors looking for a place to spend the night amid the beautiful downtown architecture. Many visitors note it is also the perfect place to stay for an experience of ghostly activity.

Among the first businesses of the booming Oklahoma Territory were saloons and brothels. As the territorial capital, Guthrie certainly had its share. Alongside fines for gambling and drinking, the early Guthrie government set a penalty on prostitution of $11 ($258 today). City records show repeat offenders time and again, giving evidence that the fine did little to stem the business.

Guthrie even featured its own red-light district, known for a whole block where window after window of flaming red curtains shone. It is said that the thirty girls from the White Elephant Dance Hall, famously fifteen blondes and fifteen brunettes, would be loaded into wagons and ride through the streets to rustle up business. Miss Lizzie may have been among the most successful madams, but she was hardly alone, though it is difficult to pin down exact numbers.

Even though brothels were an obvious part of the Wild West, they were still illegal. Because of this, though it is common knowledge that these places did exist, locating the history or even accurate addresses of such institutions is difficult. Early Guthrie city directories do not list sections such as "bordello" or "ladies of the night." What few brothels we do know about come largely from legends passed down through the generations. Some, too, are based on a hunch as one assembles bits of history. Addison Suites carries such a hunch.

Steps used by many visitors from the past lead to the Addison Suites.

Dee and I first met James at the 501, talking about using his building for our ghost tours. During the conversation, he told us about another piece of property he had. We were happy to take the short drive down the road to see if this other historical building hosted any possibility of paranormal activity.

The century-old building that houses Addison Suites consists of three floors, a common arrangement for downtown structures all over the country. The main floor at street level holds businesses; this one had long been a laundry service. The second level serves as housing, this being the home of Addison Suites. Beneath it all, there is a large basement to be used for storage. This basement has the signature red dirt floors common throughout Guthrie for over one hundred years.

When we first arrived at the building, we were invited into the main floor. There we immediately had the impression of a sweet, older woman standing far in the back of the building. She was very pleasant, a person who made us feel quite welcome. We asked James about her, and he confirmed that others had felt that there was the spirit of an older woman on the floor. He believed she may have been one of the seamstresses or workers from the time the building had been a laundry service.

He then escorted us to the basement. I felt what appeared to be strong male presence there, a rough sort of character that I believed was telling us to get out. This was his place, and we were trespassing. We did not linger.

At last, we were taken upstairs to Addison Suites. I asked James if he had any knowledge of the upstairs being a bordello at one point. He told us he wasn't aware of the building's history, except for the old laundry service. Dee and I both had an overwhelming feeling that the building did at one time house a bordello.

Once inside the bed-and-breakfast, James proceeded to show us an area that had been walled off years before. Behind the wall, which would have once opened up straight to the stairway, was a long, hidden hallway. The original old doors still stand there, each with an individual number. What was now a spacious bed-and-breakfast had once housed several small rooms. Why would a laundry need a back hall with numbered rooms? We decided we would stay the night to see if we could collect any proof to support our feelings. We were not disappointed.

We set up our cameras to cover the areas we felt might get the most paranormal activity. The first camera was located in the smaller bedroom just off the spacious living area at the front of the building (what would later become known as "Miss Kate's Room"). The second camera was placed in the living room to cover some of its open area while looking into the kitchen and back to the second bedroom. The third camera watched the Blue Room, named after the color pattern and furnishings inside. The last camera was located in the large private bath adjacent to the Blue Room.

We started our EVP session in the Blue Room and placed a KII in the middle of the bed. Time was passing without much activity accruing, so we decided to use a trigger object to see if we could get any response. If we truly were dealing with possible "ladies of the night," what better trigger objects to use than a man and money?

As our male investigator took his place on the bed, we placed a dollar bill on the table located next to the bed. We didn't have to wait long to receive the response we were hoping for. The room that had once been lit by the streetlights coming through the bathroom windows suddenly became very dark, so dark it was impossible to see a hand in front of your face. There was a change in the air, and the room became heavy. The KII started to light up fully as it lay on the bed.

The investigator jumped from the bed and said he wasn't feeling well. He was visibly shaking as he left the room. He claims that first he felt a gentle presence: a soft rustling of his hair and then a light touch on his arm. Once

The Blue Room, where men have been approached by ghostly women.

the room started to turn dark, he felt a different presence, one dark and threatening. He said he felt afraid and needed to leave. This investigator has been on several investigations in the past at multiple locations, and I have never known him to get upset or leave a site. He would not return to the room for the rest of the night.

As the night progressed, we continued to witness shadow figures and responses to our questions using the KII meter. In the early morning hours, we decided to wrap up the investigation. Veronica and I decided we would watch the monitors for a bit while the others got ready for bed. We played back several moments on the DVR system where we thought we had captured some activity.

Although we were extremely tired, we were soon to learn that sleep was not going to be easy to obtain that night. Dee and Veronica were sleeping in the living room on the pull-out bed while my daughters and I slept in the smaller room adjacent to it. Not long after lying down, the entity that we refer to as "the madam" started to manifest in the front foyer area. Dee and Veronica witnessed her running toward them and then disappearing right before they felt a hefty bump on the side of

the bed, physically moving the bed's frame. They continued to feel her bumping on the bed throughout the night.

I was sleeping quite soundly in the other room until around 5:00 a.m. I was lying on my side, facing the two large windows. Light from the street lamps poured through the sheer curtains, lighting up the room. It was all very quiet when I heard a very distinct male voice talking to me in my left ear, "This is Ms. Kate's room."

I laid there awake for a minute to compose myself. With my two daughters lying next to me, I hated to cause a stir. Finally, I decided I must be imagining things until I heard it once again, a little louder than before, "This is Ms. Kate's room."

Again I decided to ignore it. The next thing, I knew I could feel a presence leaning over me and gently poking two fingers into my shoulder as he once again said, "This is Ms. Kate's room!" I called back, "She's not here!" That was the last I heard from our gentleman caller the rest of the night.

The next morning, we all told our stories of the ghostly activities. Once I got home, I was anxious to see the footage of the night before, especially where the madam had manifested for the two investigators and run toward

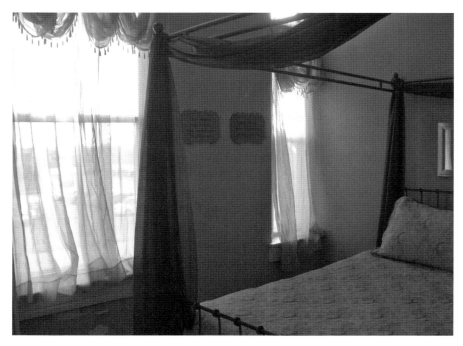

Miss Kate's room.

their bed. With the camera placement facing over their bed into the kitchen, it should have been the perfect angle to capture the activity. I set up the DVR and monitor and prepared to review our footage for night before, yet there was no footage to be found.

I was unable to find any recordings for that date or even the day before. In case there was an error, I went through all the files for that month and was still unable to locate the recordings. I then searched all the files from the year and then went back through all the files since we began using the DVR system. No files of the bed-and-breakfast could be found, even though Veronica and I had watched the system recording prior to midnight and again at 2:30 a.m. The files had been completely erased.

I informed James of the activity we had witnessed the night before and how our footage had been erased. He replied that his cousin had the same thing happen to his DVR system as well when he to tried to film his own investigation in the bed-and-breakfast. Someone in Addison Suites is carefully guarding its secrets.

Since that night, we have returned several times to Addison Suites to investigate. We continue to witness shadow figures, KII and parascope hits, people being touched and, according to some, what sounds like old phonograph music being played. One of our guest investigators reported his secure digital memory card had been erased while taking pictures. He was unaware of our previous incidents of the madam erasing our recordings.

In our continued efforts, we have been able to obtain a picture of what seems to be the entity we call "the madam." She appears in the photo looking the same way she appears to us: a white misty form in a long dress with puffed sleeves and a very angry face.

We may never know the whole truth about the history of the building, but as long as the madam continues to haunt Addison Suites, we will continue to learn what we can. Guests wishing to stay the night in a quiet little bed-and-breakfast in historic downtown Guthrie might try Addison Suites. One of the girls may even offer a turndown service for the bed.

CHAPTER 6
THE BASEMENT

THE 501 BUILDING

Just west of the old Santa Fe line in Guthrie sits a time-weathered brick building known today by paranormal investigators as "the 501." This historic building was constructed at the turn of the century and appears today much as it has for over one hundred years. A large one-story structure with a cavernous basement, it takes you on a journey back in time to its more rustic days.

As you enter the door of the 501, you are greeted by a large, heavy wooden trapdoor. When lifted, you find yourself gazing down into the dark basement below filled with cobwebs and dirt floors. As you descend the rickety broken stairs, you start to fill a chill in the air and heaviness all around.

Multiple thick wooden support beams carry the wooden slat floors above, which have lifted and cracked throughout the past century. Etched in the dirt floor, you can see remnants of what appear to be several concrete dividers, as if at some point there may have been multiple rooms or small confined spaces. On the east walls of the basement, it appears there may have once been an entryway there.

Was this perhaps one part of the secretive underground tunnel system rumored to have run underneath the Guthrie streets? If so, it would have connected directly to the old train depot, making it much easier for the transfer of incoming goods and supplies.

When I researched its history, I came across several documents showing the businesses that once occupied the building during its century-long

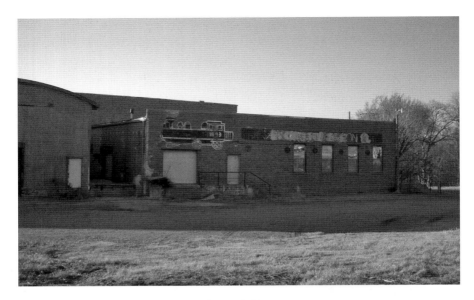

The "501" warehouse rests west of the Santa Fe Depot.

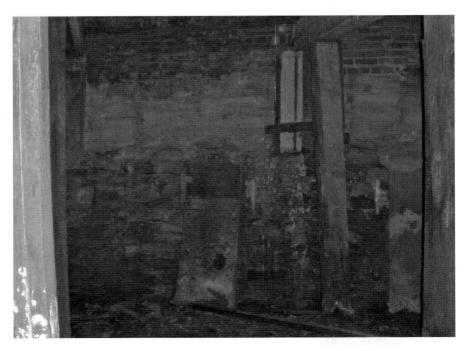

A section of wall is bricked differently than the rest of the basement in the 501, perhaps an old entrance to the legendary Guthrie tunnels.

career. The 501 has mainly been used as a wholesale supplier of fruits and vegetables and also functioned as a wholesale fence post supplier at one point. The building also shows a history of sitting empty for several years at a time, most likely being used as a storage facility. Perhaps most famously, it was used for equipment space when *Twister* was filmed nearby on the south side of Guthrie.

The rumor of the 501 being haunted, which has long wound its way among Guthrians, suddenly got national attention. According to stories told and retold, the film crew felt a troubling presence in the building, some even claiming to be "attacked" by an unseen force. It got to the point that teamsters refused to go inside. In the end, the crew left and sent a moving service to pick up their equipment for them.

We have not been able to find any documentation of deaths or accidents that might have occurred at this particular location, but this building sits adjacent to another rumored to have stored immigrant railroad workers. It is said that they were kept in very tight, confined areas and in unhealthy living conditions. They say that one of the immigrants was murdered and buried somewhere in the basement. Could those spirits be visiting the 501

Although used for storage, people say that the spirits of the building's past linger.

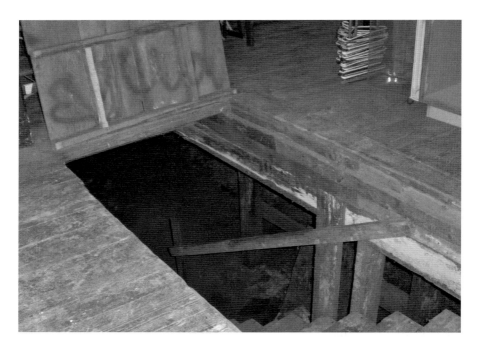

Entrance to the expansive basement of the 501.

building as well? Legends make a good story on a stormy night or sitting around the campfire, but unfortunately, without documentation and fact, they are simply stories.

Although we do not have historical proof of such claims, we have been able to collect proof of the building's hauntings. A mutual friend called one day to tell us about an interesting building he had come across in Guthrie after his friend James Long had purchased it. He told me the building had given him kind of a creepy feeling and thought we should come have a look. Dee and I were eager to make a quick road trip to Guthrie to check out a creepy building.

Once there, we both felt as if there truly was a presence in the building. We joined our guest inside and looked around the structure, taking in some of its atmosphere and energy. The open first-floor room, although a little dusty, appeared pleasant enough with the sunlight streaming through the large windows. Then James lifted the large wooden trapdoor to the basement area, and there was a notable change in the air.

We descended into the basement down an old rickety set of stairs and were greeted with a dark, wet musky smell. The large dirt-floored basement

equaled the size of the first floor and gave off a negative feeling. Dee stated that she started feeling ill with a very bad headache. She went back upstairs, and once outside, the illness subsided.

She and I talked about the possibility of returning to the building to conduct an investigation. I was excited about the chance to investigate another old historical building in Guthrie, but Dee was uncomfortable with the feeling of the presence inside. Despite her hesitation, I was able to convince her that we needed to set up an investigation for the following Saturday night.

When we pulled up to the building that night, we could feel the energy oozing from old brick building illuminated by the moonlight. We had several members of our team present as well as a guest investigator, the cousin of the owner, who had investigated the building prior.

Once inside, we began setting up our equipment. We decided to run the full DVR system with four infrared cameras. We placed two of the cameras on the first level and the remaining two in the basement area. I watched the camera feed at the monitors while the rest of the team proceeded into the dark basement to start the investigation. It didn't take long to start getting evidence that something was there with us.

Each investigator was asking questions, and our equipment was responding using words that appeared to be appropriate responses to the questions. Thirty minutes had passed when suddenly one of the pieces of our equipment could be heard saying words such as "attack" and "injure." As I watched the monitor screen, I could see our guest investigator walking slowly over to the stairs with a blank stare in his eyes. Suddenly, he fell down.

I yelled out to the team below. The monitors showed them running over to him, and I hurried to the opening in the floor that led down into the basement. With the help of a couple of the investigators, we were able to lead him up to the top of the stairs. It was then that he completely lost consciousness.

Being a nurse, my first thought was he had possibly started to have a minor seizure due to the blank stare he had when I was watching him on the screen. The guest also had a history of a stroke despite his young age. Luckily for him, we had three medical personnel on site, one of whom was a nurse practitioner. We tried to make him comfortable as I dialed 911 for assistance. Within minutes, the fire department was on the scene. As the paramedics did their assessment, I walked one over to the monitor to show him how the investigator appeared when he had first showed signs of change. While showing him the footage, the fireman pointed to a green light that appeared on the screen. I hadn't noticed it before since I was watching the investigator

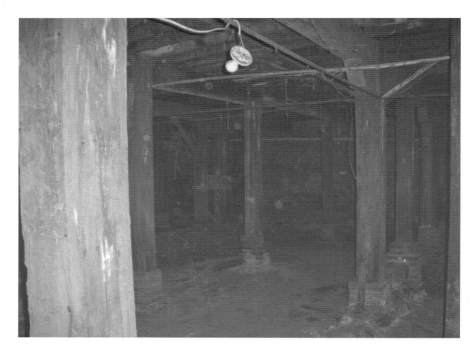

In the basement's corner, an investigator's camera caught the pale visage of a woman in a Victorian dress.

as he went down. Standing just behind him was a full-bodied apparition of a male entity.

The moment the investigator was removed from the building, he returned to his normal self. He wasn't sure what had happened. He said he was feeling perfectly fine and then all of a sudden, he felt he needed to leave. Being nurses and mothers, we all convinced him to go to the hospital to let them run some tests just in case it was a medical issue. He returned later that night to tell us that they ran several test and everything was fine. There was no medical reason that they could come up with for his earlier episode.

Since that night, we have returned on several occasions to conduct investigations. It is one of the sites we take our Guthrie tours through—after a liability waiver is signed, of course. We had not encountered any more negativity until a few weekends prior to this writing. When we do our ghost hunting tours, we like to teach our guests how to conduct an investigation and how to use our equipment. When we have larger groups, we will split up into three to five teams consisting of seven to ten people, each led by an experienced team member.

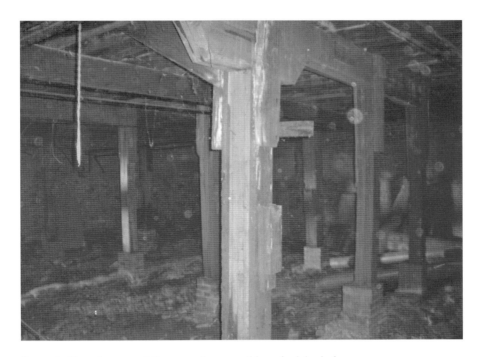

Beams hold up the ground floor, creating something of a labyrinth.

Our investigation on the last weekend of March 2015 was no different. I had received a request to do a private tour for about ten people that weekend in addition to our regular tour. After sending out the rest of the groups, I waited for our private party to show up, keeping one of my team members with me. Christine Dawson and I had already taken our group into two of the four buildings that night. The 501 was to be our next stop. Noticing that one of the guests had taken a piece of equipment from the last investigation site that belonged to someone else, I headed back to the previous site to return it. I had left Christine in charge of the group with another seasoned investigator. When I returned to the building, I decided to wait in my car so I wouldn't interrupt the ongoing investigation. I hadn't sat there long when I glanced in my rearview mirror to see several sets of running feet descending the small outside staircase. I quickly jumped out of my car to see what had happened. The younger guest, visibly shaken, reported that someone had been badly scratched. Concerned that one of our guests had been injured, I entered the building to learn that it was, in fact, my lead investigator who had received the marks. She, too, was shaking and very upset.

"We were conducting our EVP session," she explained. "When I asked the entity to come over and squeeze my hand, all of a sudden I felt as if my back was on fire!"

I pulled up her shirt and noticed four long, deep scratch marks. During the same time the equipment was saying, "Demon." Someone also reported seeing a shadow figure pacing behind her prior to her receiving the scratches. When I asked where this had happened, she pointed to the side of the basement where the green light was last seen on camera the night the last investigator was attacked.

As a mother, I immediately became overprotective. I marched into the building with three other seasoned investigators in tow. I said to the entity, "We do not disrespect you when we come to learn and research. I know you are not demonic, and I do not appreciate you attacking one of my people."

From directly behind us came a low growl. As we stood there for a few more moments, awaiting more responses, none came. I sent the group on to the next site as I waited for the next team to arrive. I felt it best to warn Dee about what we had just experienced so they could be on their guard.

I have known Christine for several years, and I know her to be an honest person. There were several witnesses to testify that she had in no way scratched herself. In fact, it would be impossible for her nails to cause the kind of damage done to her back because they had a thick overlay and were smoothly rounded. I myself watched as the scratches began to whelp and rise. I'm not sure why the entity decided to attack her unprovoked, but she remained upset for days to come.

We continue to investigate the 501 on a weekly basis. With each group, we gather more evidence of video and photographs containing images of women, children and men. We may never know why they continue to haunt the building, but we will continue to search for more answers to the mystery of the 501.

CHAPTER 7
HARVEY GIRLS

SANTA FE DEPOT

Train service came to Guthrie even before there was a Guthrie to serve. In 1887, the Atchison, Topeka and Santa Fe Railroad (AT&SF) crossed the Unassigned Lands with a new line connecting Wichita and Forth Worth. The company had been formed in 1859 to open Kansas and the Southwest to settlement. It only seemed fitting that it would be the one to open up the next frontier in Indian Territory. There were quite a few votes against the rail from tribal government and cattlemen seeking pasture, but they were overwhelmed by the economic and political clout of the railroads and those wanting to settle the prairie. Once the track was laid, it was only a matter of time.

Guthrie began as a depot called Deer Station before the Land Run settled the area. With more than two hundred miles to travel between Kansas and Texas, the steam train had to stop periodically to take on water and coal. Between Arkansas City in Kansas and Purcell in the Chickasaw Nation, there weren't any settlements for a stop, so the railroad had to create its own. Places like Norman, Oklahoma City and Guthrie were put on the map thanks to their depot stations.

In 1903, Guthrie opened the new brick Santa Fe depot that replaced the wood-frame building to the west of the tracks. The new building was 185 feet long and up to 85 feet wide, able to handle just about any amount of

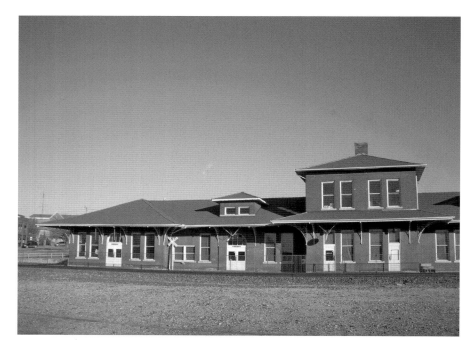

The brick station replaced the much smaller wood-frame depot.

traffic for the young territorial capital. Most importantly to hungry travelers, its north end hosted a Harvey House restaurant.

Fred Harvey immigrated to New York from Liverpool, England, as a teenager in 1853. His first job was as a busboy in the famous Smith & McNell's restaurant near Washington Park. He rose through the ranks there before seeking his fortune in the West, but the restaurant business never truly left his blood. It was a huge and growing market with customers always becoming hungry again, eager for repeat business if the service was good. Harvey tried to open his own restaurant, but business collapsed as the Civil War began. He took a job with the railroad, where he was plagued by terrible food wherever he went.

Finally, in 1873, Harvey came up with the idea of the restaurant chain. Travelers would already be familiar with the menu and atmosphere, so it would be the first place any of them would seek out upon coming to town. He used his connections with the AT&SF Railroad to start three restaurants in Kansas on a rent-free experimental basis in 1876. The experiment paid off, and by the 1930s, there were eighty-four Harvey Houses all over the country.

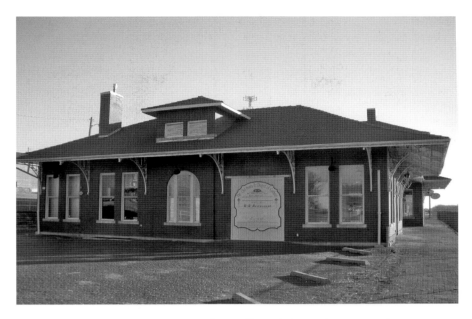

The north end of the depot, where the Harvey House fed many hungry travelers.

Harvey was a master businessman. On the one hand, he was always looking for another way to make money, including marketing through postcards and creating "Indian Detours" where camps of Native American actors sold tickets and performed for travelers. On the other hand, Harvey was famous for his obsessive customer service. He personally inspected his restaurants, where he demanded perfection along with good food. If a table was set incorrectly with its china dishes and linen tablecloth, Harvey was said to flip it over in a rage. The huckster-perfectionist businessman proved to be such a combination that there are two different stories for his last words. Some say he warned his staff not to be stingy, "Don't cut the ham too thin, boys." Others say he murmured, "Cut the ham thinner, boys."

The "Harvey Girl" was perhaps the most famous of Harvey's business creations. Newspaper ads through the overpopulated East called for "young women, 18–30 years of age, of good character, attractive and intelligent" to move west and work in the restaurants. The women were given room and board and paid the handsome salary of $17.50 a month. Tips were theirs to keep, encouraging customer service.

For every perk to the job, there were deep expectations. Girls were to be unmarried, and a strict curfew was kept in their houses. Makeup

and gum were forbidden. They wore the exact same uniform: a long black dress with long sleeves covered by a full-length white apron, with a wide white ribbon on their heads to keep their netted hair tied back. A housemother kept her eye on all the other Harvey Girls, ensuring compliance.

If a Harvey Girl failed at her duties, she would immediately have her one-year contract torn up. Yet the most common reason by far that a Harvey Girl left her job was simple: getting married. Educated, well-mannered girls from the East proved to win the hearts of wild western men.

Although this was perhaps an unintended consequence, it was one of the many reasons Fred Harvey was nicknamed the "Civilizer of the West." Another was Harvey's insistence that male customers wear jackets and ties. A man who walked in without them was offered them on loan from the restaurant. If the man refused to wear them, he was refused service. The matter of manners was taken all the way to the Oklahoma Supreme Court after a man was outraged by this rule at the Harvey House in Purcell; the court sided with Fred Harvey.

As train travel declined in the latter half of the twentieth century, so did Harvey Houses. In Guthrie, the last passenger train rolled through in 1979 when the route from Chicago to Houston ended. The R&R Restaurant kept the dream of good food and service at the depot alive for several years, but now the building stands empty.

Except, they say, for the ghost.

The specter of a lady in a Victorian dress has been spoken of for years. While the R&R was serving, some even claimed to have interacted with her. Two kids were playing upstairs in the rooms that once served as the dormitory for the Harvey Girls. After just a few minutes, they were back downstairs, explaining that the lady up there told them not to play upstairs. They went to play outside and soon came back in again, saying, "She told us not to play near the tracks, either."

In the restaurant kitchen, the R&R's owner was sometimes disturbed by things not being where she left them or the pans rattling even though nothing else shook to denote an earthquake. She also told the story that, as she was reciting a recipe to herself, a voice from someone unseen added a suggestion, "Onions!"

To this day, numerous people passing by the depot say they see a woman standing out on the platform or in the windows of the second floor, always gazing out, as if waiting for the next train to appear. Many claim that it is the spirit of Fred's wife, Pearl Harvey, come back to the restaurant.

There are a couple issues with that explanation. The Harveys kept their home in Leavenworth, and while Fred certainly traveled to inspect his restaurants, he and his wife never lived in Guthrie. Another problem: the woman Fred Harvey married in 1856 was Barbara Sarah Mattas, not "Pearl."

Stacey Frazier offers another explanation coinciding with some paranormal investigators coming up with the name "Rosalee" during their inspection of the depot. Rosalee Billings served as the housemother for the Guthrie Harvey House for many years after it opened. She was notoriously stern, very much in keeping with Harvey's expectations for his restaurants. Ms. Billings may very well still be on watch and still giving advice on how best to do things.

Frazier also discusses another ghost that haunts Guthrie: the girl on the track. For decades, a number of railroad workers have spotted a young woman in a pale blue dress walking the tracks. She never seems to react, despite the frantic engineer blowing the whistle to have her move out of the way of the unstoppable train. One man even came back to Guthrie after his run, trying to find out what happened to the girl he hit. No one knew anything about anyone being hurt, and searches never turned up a body on the track. There have been deaths on the railroad, including an engineer who passed away quickly of a heart attack while he pulled into the station, yet the oral history of Guthrie answers the mystery of the young woman.

The story is of a Harvey Girl named Evelyn. She worked at the restaurant a century ago while her fiancé, Howard Wellston, served in Europe in World War I. They regularly exchanged letters as engaged couples do, but one day Howard's letters stopped coming. Evelyn continued to write, but he didn't reply. Had he given up on her and found a new love abroad? Had he been killed in one of the battles that claimed so many thousands of American boys?

The questions plagued Evelyn. She became distracted from her work, gaining the ire of Rosalee Billings. During her time away from waiting tables, Evelyn began to take long walks along the tracks, keeping an eye out for the next mail train to come through, perhaps with news from Howard. When Evelyn broke curfew out on her walks, Rosalee threatened to end her contract, but it did no good. Eventually, Evelyn didn't come back; a train had struck her as she walked in a forlorn daze. She was wearing her pale blue dress.

Weeks and months passed, and then a veteran of the war walking on crutches arrived on the train. It was Howard, finally back in the States on

medical discharge after being severely wounded. He had not received any letters from Evelyn since he had been in the hospital, and the letters he had written during his rehabilitation went unanswered. Rosalee Billings, who had kept Evelyn's things in a box along with the letters that arrived too late, returned them to him. He left, but his spirit never seemed to. Nor did Evelyn's, still wandering the tracks, waiting to hear from him.

CHAPTER **8**

THE BLACK JAIL

FIRST TERRITORIAL PRISON

Noble Avenue is often referred to as "Church Row" with its many houses of worship one after the other. As drivers come into Guthrie from I-35, they pass the beautiful brickwork and stained glass of one denomination after the other: Christian, Episcopalian, Methodist, Baptist and Presbyterian.

Yet at the far west end, just before the land gives way to Cottonwood Creek, there stands the ominous Black Jail. This, too, once served as a church, although its history goes back further to a much darker time. Today the Black Jail stands empty, though there are many rumors among Guthrians of spirits who have never left the confines of the old prison. The shadow of a man is said to stare out of cell windows and lurk in the narrow halls. A woman in a Victorian dress walks, singing hymns on the former grounds, now alleyways between homes. And the sounds of unseen children laughing and running ring out even when the few who go into the jail are alone.

Historically, there have been two "Black Jails" in Guthrie. The first was the county jail, nicknamed such for its massive use of iron. Windows, cell doors and seemingly everything was made out of iron in the wild booming days of "First County," which would become known as Logan County in 1890. Today the county jail at the Logan County Sheriff's Office on Broad Street has its own host of ghost stories from suicides and murders, such as that of Jerry Emerson in 1903, shot by an escaping inmate. Stories tell of

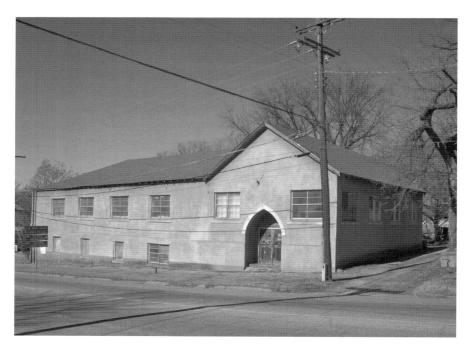

Today the Black Jail stands empty.

apparitions seen still hanging from the rafters in cells and the kitchen and inhuman sounds made by no living soul.

The "Black Jail" people speak more about was built in 1892. The Land Run was an unprecedented affair, and Guthrie stood at the heart of Oklahoma District as a town born outside the law. It was under federal jurisdiction as far as anyone could tell, but because the Unassigned Lands were not strictly part of Indian Territory, it was difficult to say where exactly local law began. Many took it into their own hands.

While the idealism of the era said that the land would go to those most suited to prove it up through their tenacity in making the Run, the truth proved otherwise within hours of the opening gunshot. Claim-jumpers roved the countryside a little slower, finding the good claims and recommending with their sidearms that the folks who got there first should find another. Still more gunplay arose when runners discovered more than one person had tried to stake a claim. Civil courts were still days away, and judgments could take months or years to settle fully. Rather than wait, a quick flash of a Winchester or a Colt could settle the issue then and there. Many people

gave up the land for the sake of their lives, others fought back and some met their ends through the bullet.

There are an untold number of stories of violence during the Run, but a few proved well documented. Two miles northwest of Guthrie, C.T. Land made his claim only to discover that it was also claimed by one Mr. Campis. Land told the others to leave and, after they declined, opened fire. Campis then fled, dying from his wounds within minutes just yards away. The story of Campis's murder trickled back to Guthrie, where a thirty-man posse came to collect Land for trial. Land refused to give up, running about twelve miles before they caught up with him and blasted him full of holes in a firefight.

Yet for every tale of violence, there are hundreds of cases of happy settlers staking their claims and beginning rugged but productive lives. The murders, of course, gained more public interest, and they were widely published in newspapers and magazines back in the States. Secretary of the Interior John Noble (who would have a town named for him down the railroad tracks south) reported that accounts of calamity and mass bloodshed were all false. This paradisiacal view of Oklahoma District proved extreme in the other direction.

Murder came to Guthrie itself less than four months after the Run. Three business partners, Townsley, Stevens and Winters, came to Guthrie from Chicago to set up a grocery store on what would become Harrison Avenue. While Townsley and Winters got their store going, Stevens left his lot in their charge while he went out of town for business (professional gambling). When Stevens returned on August 6, he was outraged to find his own building boarded up, not run by his partners as he had anticipated. Stevens drew his gun to show how serious he was. Townsley must have believed him as he pulled his own gun and shot Stevens, which he claimed to be self-defense. The courts agreed, although Townsley soon left town.

Today the site of the first murder hosts the Jungle, a bar with a modern, animalistic, tropical vibe. Servers and patrons of the Jungle say that the men are still arguing. Odd things happen from time to time, such as the karaoke machine shutting itself off. Skeptics point out that it could be an electrical issue, but no one has an explanation for the glass that flew across the room. Without any living soul near it, the glass leaped from its shelf and went several horizontal yards before shattering on the floor. Upon hearing the story, one man asked, "Flew or fell?" The woman who had witnessed it replied, deadly serious, "Flew."

The years after the Land Run gradually became more settled, but Oklahoma Territory continued its tradition of roaming outlaws. In records

collected by the WPA Writers Project in the 1930s, Nellie Trimm recalled the tale of the time in the fall after the '89 Run that two men appeared on her front porch. Her husband worked for the Santa Fe Railroad and was three hundred miles away while she suddenly faced strangers with guns. They asked where Mr. Trimm was, and Nellie replied, "Just down the creek a ways, with his gun." The men suddenly lost interest and left. It was only long after that when Nellie recognized the men from their pictures: Zip Wyatt and one of the Dalton boys.

Clifford McCubbin stated that he knew "the Dalton family since the early 1890s" and stayed in touch with the famous outlaws' sister Leona as late as 1953. She noted, "The only reason the boys started to outlawing was that they were all heavy drinkers of whiskey." Miss Leona was happy to admit to any of her brothers' robberies, including the famous dual bank robbery in Coffeyville, Kansas, in 1892 that resulted in a shootout that left eight men dead, four on either side of the law. She was also adamant about crimes they did not commit, including the train robbery at Red Rock that many ascribed to them.

To help control the wildness of the new territory, the federal government contracted with a local Guthrie company to build a territorial jail. Among the company's board members were the Reeves brothers, whose casino just down the street generated plenty of crime. One of the first institutions in Guthrie, the Reeveses bragged about their doors being open every day and every night until it was closed down by the onset of prohibition at statehood. When they finally had to close up after fifteen years without the locks being used, they realized that no one had a key.

In January 1893, the territorial jail was put into service. Thanks to its native sandstone walls that stood eighteen inches thick, it was virtually impregnable, except through the narrow windows. The poor ventilation made the jail notoriously stifling, yet it was enough to let in freezing temperatures in winter and miserable heat in summer. Only a little light got into the windows, and the dim shadows won it the long-lasting nickname the "Black Jail."

The building became a bragging piece for tough justice, from politicians denouncing crime in the territory to mothers warning their children. No one would argue with the hardships of life in the Black Jail. During his summer legal battle, the hapless president of Oklahoma University was held there, and the *News Leader* noted, "The appearance of Professor Buxton showed that prison life in this hot weather was telling on him." Buxton's stint in the federal jail was said to have wrecked his health for the rest of his life.

Yet the Black Jail proved not to be escape proof. In 1896, outlaw Bill Doolin led a gang in a daring escape. McCubbin gave thorough details in his memoirs of Doolin's audacity. He and another inmate had been planning for several days in advance, but they decided to wait until after the Fourth of July, as that would be the only American thing to do. Through a combination of bribery and surprise, the two men rushed the front door after nightfall to escape. First came high promises that convinced two guards to let Doolin and four others out of their cells. At the west stairway, they came across an armed guard, whom they pushed down the flight of stairs. After taking his gun, they fled down the tracks several miles until they were out of Guthrie. They came across a young couple out for a midnight ride, held them up and took their horse and buggy. When the gang split up, Bill took the horse and rode it all the way into the Creek Nation, where he set it to pasture. A rancher later returned the horse when the owner posted a reward for it.

While the story of Doolin's escape is famous, at least one prisoner never left the Black Jail. In June 1907, James Phillips was held in the Black Jail after having killed a man in the Wichita Mountains forest reserve. The *State Capital* tells the story of how his appeal to the Supreme Court was refused, prompting the death sentence to be carried out. As Phillips was the first white man in the territory found guilty of murder, the jail had to build gallows. It did so straight across the street, in perfect view of Phillips's cell window. While Phillips was forced to watch the assembly of his demise, "religiously inclined people had been visiting him in great numbers, and picturing in the most somber colors the fate which would await him if he died unrepentant, and this had wrought greatly on his mind." On the morning of Phillips's execution, the guards came to his cell to find him already dead. It was a shock, since Phillips was a large, burly man who certainly wouldn't have gone down without a fight. Instead, Phillips had "dropped back on his cot, killed, so the doctors stated, by fright."

After statehood, newer federal facilities were built, and the Black Jail ended its term as a prison. The owners then became the Nazarene Church, which added another center of worship to "Church Row." The Nazarenes added a large chapel on the east side and used the small cells and rooms for Sunday school. Many Guthrians to this day remember, along with the Carnegie Library, it hosting Teen Town, a social club to keep kids off the streets.

Eventually, the church moved out, and another group moved in: the Samaritan Foundation. Guthrians were curious about the secretive new group, but they had no idea how far its mysterious beliefs went until

Jonathan George came from Massachusetts with a judge's order to reclaim his children. Suddenly, the Samaritan Foundation became front-page news.

Linda Greene, the leader of the group, routinely led seminars on dowsing and wrote extensive materials about the corruption in modern society. Her discussions were based on principles of energy, with positive energy being drained away by vampires and zombies. She said many of these monsters masqueraded in plain view as celebrities. President Bill Clinton was "an animal-mutant zombie"; his wife, Hillary Clinton, was a "three-virtue type zombie"; Madonna a "Nephilim zombie"; and Rosana Arquette was a "ray/octave zombie." Fortunately, with Greene's help, people could defend themselves from these soulless celebrities and even send waste-energy that left people pent-up into them. Another method to live more freely was to send "stray obsessive energy" into soy milk and then pour it down the sink.

Greene brought dozens of followers into the Samaritan Foundation, preaching on topics of alien abduction and demonic possession. Barcodes on the backs of packaging were said to be evil, and drawing a circular sigil could protect people from them. Telephone wires allowed vampires to sap the souls of those who used them, so conversations needed to be kept to a minimum, if held at all. The safest place of all was to be in Greene's immediate congregation, which she housed in the Black Jail. People were rarely allowed in or out, and the building was a mystery.

After Jonathan George's arrival in 1993, police investigated the Black Jail. They found thirty to forty people living there, fifteen of them children. Holes stood in the roof, allowing birds to nest inside. In some rooms, piles of pigeon droppings stood four feet high. Since there was no running water, a good deal of human fecal matter was said to be added to the heaps.

The Oklahoma Department of Human Services condemned the building in 1995. Before police arrived to clean out the place, however, it was abandoned, and the Samaritan Foundation disappeared to Wyoming. Neighbors whispered that they had seen a Ryder Truck back up to the building at night, and in the morning, the only things left behind were rumors. Federal investigations began to look at possible links to the Branch Davidians.

Since then, the Black Jail has stood empty, although there are many who say the spirits of its convoluted past still remain. Most famously, paranormal investigators and those walking through the building have heard the sounds of heavy footsteps and the rattling of iron chains. Several people talk about seeing the shadow of a large, burly man walking the halls or, more often, standing in a cell, staring out at something none of them can see. From his

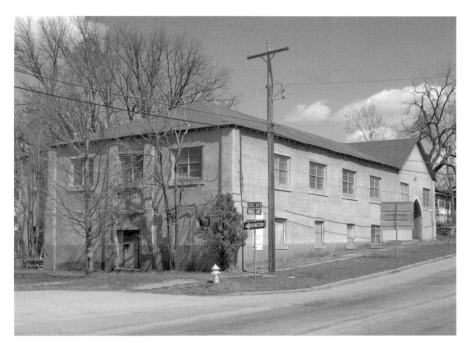

A renovation project has stabilized the Black Jail's roof, but its future remains a mystery.

size, they say that it is the ghost of James Phillips, still afraid to leave the prison and face the other side.

Another ghost is said to roam the grounds outside of the Black Jail. Many people have claimed to see her, a woman in Victorian-style dress walking while carrying a thick book that is said to be a Bible or hymnal. More than just appearing, she is said to sing haunting hymns that echo through the night. The lady is said to be Phillips's wife, who came among the "religiously inclined people" to comfort her husband as his sentence approached. Others say that she is from the Nazarene Church, still attending services despite the world having moved on.

In addition to these two, there are plenty of other cases of hearing running footsteps. Many claim that children's playful laughter can be heard both inside the Black Jail and in the alley behind. One can only wonder what spirits these may be.

CHAPTER 9
THE OUTLAW WHO WOULD NEVER BE CAPTURED ALIVE

ELMER McCURDY

Scary stories of haunting usually center on a disembodied spirit, yet Guthrie holds a unique tale of a "dispirited" body haunting sideshows and television. It is an urban legend come to life.

The Six Million Dollar Man was filming in Long Beach, California, at the Nu-Pike amusement park's "Laff in the Dark" ride. It was a classic, the kind seen all over America, in which a small train takes guests through a shadowy tunnel where spooky soundtracks and jumping animatronics thrilled carnival-goers. One of the special effects was an "ancient Indian mummy" painted bright orange that popped out of a coffin. A film crewman went to move what he thought was the wax dummy, and its arm broke off in his hand. Instead of being a dull lump as a wax dummy should have been, the arm had a bone protruding out of it. The crew investigated the surprisingly realistic dummy further and found it to be actual human remains.

The body in question was that of famed latter-day outlaw Elmer J. McCurdy, a man of seemingly endless bad luck. McCurdy was born in 1880 in Maine to an unwed seventeen-year-old mother. His uncle George and aunt Helen adopted McCurdy as their own, but George McCurdy died of tuberculosis when Elmer was only ten. Helen (whom he had always been told was his mother) and his actual mother worked to raise the boy, and eventually they confessed the truth. The news broke Elmer's heart, and he became a violent, troubled teenager. Alcoholism soon consumed him.

After losing many more of his family to disease, including his birth mother, McCurdy began wandering south from Maine and then west. He found work as a miner, but he routinely lost his jobs due to heavy drinking. In 1907, McCurdy joined the U.S. Army, serving a three-year stint while undergoing training for machine guns and explosives, especially nitroglycerin. Just twelve days after his honorable discharge, McCurdy and an old army buddy were arrested on suspicion of conspiracy to commit robbery. They had gathered together an impressive set of tools suitable for safecracking, which McCurdy assured the court were part of a project the two had begun: inventing a foot-controlled machine gun. He was acquitted on January 30, 1911.

The next, and last, eight months of McCurdy's life included a wild career as a bandit. Perhaps it was because he beat the law, or perhaps he was introduced to professional criminals like Walter Jarrett while in jail. The golden age of Wild West bandits had passed by more than a decade, but McCurdy saw fit to try his own hand at forming gangs and making legendary robberies.

Unfortunately, the robberies often went spectacularly wrong. His gang's first famous attempt was holding up the Iron Mountain–Missouri Pacific train in March. They successfully stopped the train and boarded it, but McCurdy overestimated his use of nitroglycerin to open the train's safe. The door blew off, but the explosion also tore the cash inside to shreds and melted all of the metal currency. They managed to collect just $450 out of the potential thousands there, and McCurdy stole the mail clerk's gold watch.

After the robbery, the gang turned on McCurdy (perhaps for obvious reasons). In the ensuing knife fight, he earned slashes on his left wrist, face, head and neck. He survived and left the group, wandering to wherever he could find a place to stay, often at the ranch of Charles Revard outside Bartlesville, Oklahoma. While McCurdy and the ranch hands drank, the other members of the gang returned home only to be caught red-handed with the loot by local law enforcement.

McCurdy was well known for this Iron Mountain debacle as well as a bank robbery in Chautauqua, Kansas, in which he blew open the vault but not the safe inside it. There, his new hapless gang stole over $100 in coins and fled with heavy pockets. Despite these famous flops, there are a number of other unsolved robberies that happened over the course of the spring, summer and fall in 1911, all within forty miles of Bartlesville. Trains were robbed in Lenapah and Okesa, a station in Dewey and a bank and general store in Centralia. All involved a small group of three

to five bandits and use of nitroglycerin. McCurdy might very well have been successful in these capers, especially as he was never caught for them.

McCurdy's final robbery was meant to be his greatest haul. A "Katy" train on the Missouri-Kansas-Texas line was carrying $400,000 in cash for the annual Osage Nation royalty paid by the federal government. McCurdy's newest gang swooped in and stopped a train only to discover that they had gotten the wrong one. This simple passenger train had little to steal, so the men made off with another watch, $46, a jacket and two bottles of whiskey. McCurdy brought the whiskey back to Revard's ranch and shared it with the hands before sleeping it off in the barn.

That night, one of the gang was caught, and he quickly confessed that McCurdy was at the ranch. A posse formed, including Stringer Fenton, Governor Haskell's former state enforcement officer in the prohibition of alcohol who now worked as an agent for the Katy Railroad. The posse surrounded the barn where McCurdy slept and waited for dawn to call him out.

When he finally woke up, McCurdy refused to give in. He fired at Stringer's brother Bob, which set off a gunfight that lasted for more than an hour. During the fight, McCurdy cleverly changed places in the hayloft of the barn, always maintaining cover. Stringer Fenton determined a pattern to McCurdy's movements and made an estimated shot. The barn fell silent.

The men sent in a kid from the ranch to ensure McCurdy wasn't feigning. He wasn't. McCurdy's body was found wounded in the neck from a shotgun blast and finished off by Stringer's bullet. He was still carrying the gold watch belonging to the mail clerk on the Iron Mountain train.

McCurdy's remains were taken to Pawhuska, where undertaker Joseph L. Johnson would need to hold them until family came to claim them. Johnson set to embalming the body, using a particularly potent concoction of embalming fluid heavy with arsenic just in case the legal process took awhile. Johnson's son, Luke, recalled, "Month after month went by and no claimant was ever found…Then, about six months after embalming, it was noticed that preservation was still apparently perfect…the tissues were gradually taking on the appearance of being ossified."

Johnson's mortuary became something of a showcase to curious locals. Luke Johnson later wrote, "As the 'Embalmed Bandit' had already become an object of local interest, we dressed him in the clothes he had worn at this last fight…someone placed a rifle in the bandit's hands, and there he remained in our Mortuary for five years."

Elmer's postmortem fame spread, and soon a call came in from previously unknown family members in Kansas City, Kansas. A pair of men arrived, identified Elmer as a long-lost loved one and took him away. Johnson may have been suspicious, but the men had notified the sheriff and gotten permission. They left with Elmer on a train.

If Johnson had any suspicions, they would certainly have been confirmed as news came to Pawhuska that "Johnson's outlaw" was on tour with the Great Patterson Carnival Shows. It had coincidentally been in Arkansas City, Kansas, just forty-five miles away, when Elmer's "relatives" arrived. Upon hearing of Elmer's potential for show business, the Patterson brothers had conned their way into getting his body and put it on display as "The Outlaw Who Would Never Be Captured Alive."

After the carnival, Elmer McCurdy served for forty-six years in Louis Sonney's Museum of Crime, where his oddly textured body was taken to be a wax dummy. Over time, he changed shows and museums, appeared in the 1967 film *She Freak* and wound up a little worse for wear as part of Nu-Pike's amusements. When he was rediscovered, he once again came into custody of police, now at the Los Angeles County Coroner's Office.

While undergoing intensive autopsy, the coroner discovered trinkets stuck into McCurdy's mouth, including a 1924 penny and a ticket stub from Sonney's Museum of Crime. Police determined the identity of the mummy, and national newspapers spread the word. The question now became, "What to do with it?"

The answer came from Guthrie. The Indian Territory Posse of Oklahoma Westerners club of history enthusiasts met at the *Daily Leader* offices for coffee and talk every week. When the topic of McCurdy came up, Fred Olds, director of the new Oklahoma Territorial Museum that had just opened up four years before, determined that they should do something. Calls were made, and eventually the body was turned over to the Oklahoma State Medical Examiner after, once again, no family came forward to claim the body.

Elmer McCurdy was given a funeral procession in a horse-drawn carriage on April 22, 1977, as part of the '89er Day celebration. The hearse brought McCurdy to the historical Boot Hill in Summit View Cemetery, where he was laid to rest with his fellow outlaws. McCurdy's grave is just a few feet away from that of Bill Doolin, who met his own end from a lawman's gun on August 24, 1896, after nearly two months on the lam from the Black Jail. Before Doolin was buried there, he was brought back to Guthrie and put on display in the bank in the Gray Brothers building as a warning to all other

Elmer McCurdy rests in good company on Boot Hill.

would-be bank robbers. McCurdy, eighty years later, had something of a hero's welcome.

Louise Boyd James, who attended as an Oklahoma history teacher at Guthrie Junior High, described the affair as "a fine funeral." She brought along with her fifty young students to watch while members of the Oklahoma Historical Society, some of them lawmen, served as pallbearers and lowered McCurdy to his final resting place by lariats. The tone of the service was serious and forgiving toward McCurdy's violent end with the reminder from Luke 6:37, "Judge not, lest ye be judged."

A concrete slab two feet thick was poured over the grave to ensure the body that haunted the American West for the better part of the twentieth century finally stayed put.

ALL THE WORLD'S A STAGE

THE POLLARD THEATRE

Droves of Oklahomans, as well as folks from out of state and out of country, flock to the beautiful building known as the Pollard Theatre every year. Built in 1901, this building originally was the site of Patterson Furniture. The wood carpenters who worked at Patterson's made the coffins for the town of Guthrie, which made it easy for Patterson's to also function as a funeral parlor. A coffin was the last piece of furniture a person would need.

In 1919, future Guthrie mayor George A. Pollard purchased the building and converted it into a vaudeville house where silent films were popular until 1929. Guthrie was no stranger to shows; the first opera tent was set up within a week of the Run. Within a year, Guthrie had the McKennon Opera House, which had a standing handshake agreement with the territorial legislature to host its assembly. In 1899, the 1,100-seat Brooks Opera House was built, giving young actor Lon Chaney work as a stagehand and hosting Oklahoma's constitutional convention between shows. As vaudeville declined and the golden age of cinema took off with talkies, opera houses closed, and the Pollard Theater became the Melba.

In 1986, a developmental grant was received, along with private donations, which made it possible to convert the building into what it is today. The Pollard is now a professional theater company offering plays year round. Yet the Pollard holds on to the glory days of its past with original murals, a tin

Theater in Guthrie began within days of the Run of '89. *Courtesy Bob Bozarth Photography*.

ceiling and wrought-iron chandeliers. Some say even the spirits of players long gone still linger.

Involved in community theater myself, I had heard of the historic theater many times as one of Oklahoma's premier institutions. I had never actually stepped foot into the building nor heard about its ghostly tales until October 2014, when the Guthrie Chamber of Commerce contacted the Oklahoma Paranormal Association. They asked if my co-founder Dee Parks and I would join them to do an interview with Fox 25 News about the events we were doing in Guthrie for Halloween. After our interview, we were asked by the news crew to join them at the historic theater. Since they had heard of the building being haunted, they wanted us to bring along some of our equipment. We were more than happy to comply! We grabbed our KII, our recorders and FLIR and headed to the Pollard. Once inside, it became obvious that the historic building was home to many spirits.

It was between camera shots that I first noticed a man standing on stage. It had been set up as a cabin for the production of *Evil Dead—The Musical*. The camera crew, theater personnel, Dee and I were all out in the seating area discussing what to do during the next take. No other living person was in the building, yet there the man stood on stage.

As the others talked, I stood frozen in place. I locked eyes with the man standing center stage. Aware that I was the only one seeing him at that time,

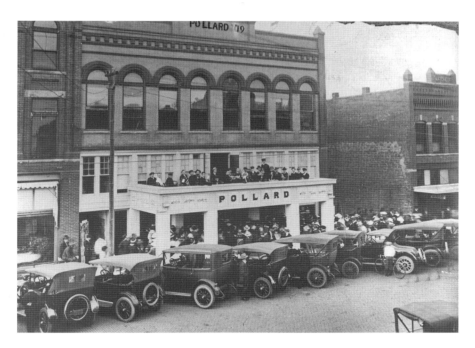

Eager theatergoers visit the Pollard in the 1920s. *Courtesy Bob Bozarth Photography.*

I decided to ask him his name. The name "Charlie" immediately came to mind. I also felt that he was a manager of sorts, the one who was in charge.

Then he was gone.

The funny thing about seeing a spirit is that no matter how many times you witness it, you always doubt yourself, and you always feel funny bringing it up. Still, something was pushing me to ask the others. I turned to a couple of the staff members and asked them if there has ever been a "Charles" or "Charlie" who worked there. I told them he would have been a manager, most likely a stage manager who was often seen running behind sets. I also pointed out that he would not be living at the time.

It appeared I had caught one of the staff members off guard. When he collected himself, he went on to confirm that there was indeed a stage manager who went by the name of "Charlie." I then told him what he had looked like and how he would be seen walking behind stage. He confirmed all that as well, flabbergasted.

Coming from a small community theater, I wasn't sure what the stage or dressing rooms were like at the Pollard, but I kept getting a mental picture of a catwalk to stage right. I felt as if someone was often seen walking back and

forth there. The Pollard staff was then nice enough to show us the catwalk I just had pictured, stage right. Just as I described my feeling, he confirmed that many people had seen or felt someone walking along that catwalk. He added that many theater staff refused to be left alone there.

I had also felt as if there was a young child there, but no one could tell me anything about that. It was not until a few weeks later that a friend of mine and I decided to go on the Guthrie ghost walk. When we stood in front of the Pollard Theatre, Stacey Frazier began telling the stories of the theater, which included the ghost tale of a small boy.

Hubert Wester was the nephew of a costumer and prop mistress at the Pollard during the days of vaudeville. Every summer, his parents sent him from Oklahoma City to "the country" in Guthrie to stay with his aunt. The story goes that one afternoon, he was playing with his dog, running up and down the stairs. His aunt told him to quit it, so he started a quieter game of catch. On one throw, the ball went out the open front door into the street. The dog followed it, and the boy ran after his dog. Both were struck by the trolley on Harrison.

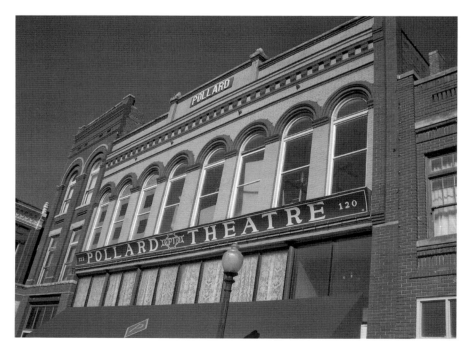

The Pollard Theatre still stands proudly today.

Hubert lived, though his dog did not, and he earned a painful limp that kept him from running and playing the rest of his days. He later moved to Guthrie, where he hung out with others like Ivan Ridge on the stoop of the Gray Brothers building. Many hold that he still stays at the theater of his youth to this day. They say that, just as a show begins to start, people on the east side of the theater near the old stairs can hear barking, a bouncing ball and a child's laughter, reliving the last moments of innocence.

I knew I had felt the presence of a small child, but I felt as if it had been a young girl. Since children as well as other adult entities were present there, I was trying to figure out why a theater would be host to so many souls who appeared to be walking around freely throughout the building. When my research on the building came up with an article that mentioned its past as a funeral home, the pieces began to fit together.

The stories continue about the haunting of the Pollard Theatre. One of the most repeated is the tale of audience members looking in the mirror during intermission and seeing the face of an angry little old man glaring back at them.

When visiting the Pollard, remember to keep an open eye. The actors of today share the stage with those of years gone by who may be glimpsed for just a moment before their show ends again. After all, life is but a stage, and we are merely its actors.

CHAPTER 11
THE BANKER AND THE BARBER

GRAY BROTHERS BUILDING

The towering gray Russian capped oriel and fringe atop the bold dark brick with its native sandstone arches is one of the most iconic images of downtown Guthrie, as it has been since nearly the beginning. This is the standout feature of the Gray Brothers building, believed to be a prime example of the ornate style of architect Joseph Foucart, sprawling from 101 to 103 West Oklahoma Avenue as it has since 1890.

In the years before the '89 Run, William H. "Harry" Gray came from Canada to Udall, Kansas, where he set up a grocery store and earned his American citizenship. When the government announced the opening of the Unassigned Lands, Gray determined that this would be yet another opportunity for him to move and better himself. On the day of the run, he, along with his brother, George, staked out a town lot that would eventually become the west end of the building that would bear his name.

The early days of Guthrie proved so lucrative for Harry that he pooled his resources with George to buy the lot to the east of his own, which now had become a prized corner where Division met Oklahoma, the crossroads of a town that looked to be the crossroads of the district and, someday, the state. It was a heavy investment as they put up a three-story building with the bottom level being an expansive basement, yet it proved to be a good one. By 1903, they had torn down Harry Gray's original wood-frame grocery and

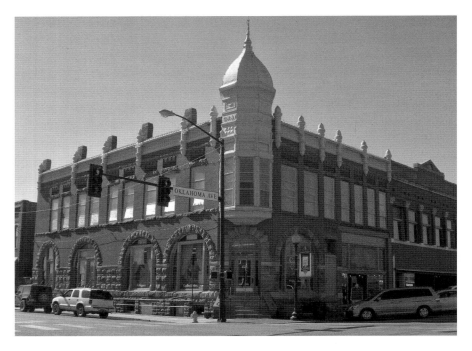

The expansive Gray Brothers building at the crossroads of Oklahoma.

expanded their building to the west. Soon the Grays retired and served as landlords, with Harry Gray maintaining a careful watch over the building from his private office on the second floor.

The rest of the building was packed with business. Another pair of brothers, F.E. and J.F. Houghton, took over the grocery and, with so much capital needed in the new Oklahoma District, added banking services. The Bank Grocery is recorded in the 1903 Territorial Directory at 103 West Oklahoma, with two more banks next door: the Bank of Commerce and the Bank of the Indian Territory (which would later become Oklahoma State Bank).

The basement, originally meant for storage with ample access both from the inside and out, was turned into a barbershop. With a prime location and even a slew of potential customers just upstairs, the barbershop thrived. Businessmen from every direction came into the shop for trims, shaves and a relaxing bath.

The *1910 Review of Industrial & Commercial Guthrie* includes a block for "Gordon & Ridge, Barber Shop and Baths." The two men had "recently

taken charge of the long established Danderine Shop" and were described as "expert workmen, hustlers, clever, good citizens, and firm believers in the future greatness of the capital city." While the state capital may have moved, the sense of the chamber of commerce was still a very positive one. Its bright language describes Gordon & Ridge in glowing terms: "The establishment is under the Oklahoma State Bank and contains four chairs, which are kept occupied most of the time. Messers, Gordon & Ridge will have nothing but the best, cleanest and most modern work, and they have a large and constantly growing list of pleased customers." The barbershop lasted through the Depression, and A.L. Ridge's son Ivan got into the family business, eventually taking over the shop.

The Gray Brothers building has hosted numerous offices over the years. The Guthrie school system had its early administration set up there. The first telephone exchange also operated out of the second floor by 1893 with live operators manually connecting switches. Most famous, of course, are the banks whose lobbies rested on the raised first floor. The iron-reinforced vault still stands with its ornate and heavy door.

Today the building serves as commercial space for Country Corner Antiques and Treasures & Books. The bank vault is lined with mirrors and holds the valuable collection of old china and glass dishes.

There are those who say something unearthly lurks amid the shelves of collectibles. In fact, the Gray Brothers building is said to host two ghosts, both very different in personalities. The proprietor of Country Corner describes the first as "our friendly ghost." He is said to be a former bank teller, perhaps H.W. Painter of the Bank of the Indian Territory or any of the many young men who got their early experience in the business world by handling money. With the large number of tellers in the history of the building, it is difficult to trace who may have returned to his position after life.

The teller ghost usually appears as a busy phantom. Customers perusing the antiques—particularly those near the vault—often feel a cold breeze but only for a moment. Rather than the standing "cold spot" usually attached to a ghostly presence, the teller is always on the move. The teller is also seen, perhaps even more frequently than felt. He can often be spotted out of the corner of a patron's eye or, at best, seen as a shadow reflected in the vault's mirrors. The appearances are never very long; usually he is walking in a flash or may stand but disappear as soon as the startled viewer takes a second look. Those who get a comparably good look at him talk of him wearing an old-fashioned suit.

Staff members at the Country Corner seem proud to have such a business-minded entity with them in the upper floor. They cite no real issues with the other spirit lingering in the basement, except for the notorious wafting cigar smoke. While the identity of the teller ghost is in question, most believers of the paranormal who run across the strange basement spirit agree that it is none other than barber Ivan Ridge.

Ridge—or "oh, that Ivan," as many older Guthrians remember him—was a major personality in the town for decades. He was the only child of parents who had come to Guthrie with the Land Run. The senior Ridge's early barber shop was in the block at Harrison Avenue and First Street, where the family lived in an apartment above. Ivan Ridge grew up from a gregarious boy into a "large man," "tall and big," as some described him. Others added that he was "burly, and scary, with tattoos all over."

While he had other shops, Ridge was best known for his space in the Gray Brothers building, where he followed in his father's footsteps. There he would give haircuts and shaves, shooting the breeze with customers as he did. Between customers, Ridge would hang out at the edge of the building, smoking one of his ever-present cigars in the fresh air and playfully puffing it into people's faces when they talked. If someone walked by him too closely, he would slyly stick out a shoe, tripping them up with his long, beefy leg. Then he'd guffaw and chastise the victims of his pranks who didn't see the humor in it themselves.

Ivan Ridge with one of his prized motorcycles. *Courtesy Al Bryan.*

One Guthrian shared her family's memory of Ridge working away in his barbershop and then banging on the pipes to tell his wife upstairs that he was ready for her to bring down his lunch. Ridge was married between four and eight times; local researchers in the Guthrie Genealogical Society have had difficulty pinning down the exact number. Although there is debate about how many wives Ridge had through his eventful life, everyone agrees that the divorces were "unpleasant."

In addition to stories about his character, Ridge was famous for his great loves: motorcycles and cigars. He combined the two in regular excursions as he hopped onto his motorcycle with its sidecar and drive southeast all the way to Florida. There he would board a ship to Cuba in the days before the communist revolution and, after a relaxing vacation, return with his sidecar packed with boxes of smart Cuban cigars.

Ivan Ridge passed away in 1981 at the age of eighty-two. His body is buried in Summit View Cemetery between his parents. Yet many Guthrians believe that Ridge never really left.

Laurah Kilbourn's Extra Special Fabric store had its shop in the basement rooms of the Gray Brothers building before it moved out in 2006. The space often smelled of Ridge's strong cigars, but Kilbourn never thought much of it. With the amount Ridge smoked, the smell certainly would have worked its way into the woodwork. It was peculiar, however, that the cigar odor sometimes seemed stronger than others, as if it had been freshly lit. No one had further explanations how wafts seemed to appear on the street outside, either.

More evident was when Kilbourn found "stuff knocked on the floor." They were mostly dresses, which were hung on hangers and could not possibly have fallen without being lifted. Patrons to the store even said they watched things suddenly fly off the shelves or the racks as if someone had given them a smack with a big hand. She was glad to move to her new street-level shop down Oklahoma Avenue, even if it turned out to be haunted as well.

To this day, people say they can smell wafts of cigar smoke in the basement of the Gray Brothers building and even on the sidewalk where Ridge once took his breaks. The smoke comes so thick that many people have claimed to see full puffs appear right next to them. The clouds are just as if someone blew them out, yet no one living stands there.

Ridge also seems to get around town. Nelda Brown of the Guthrie Genealogical Society recounted the time a man came in from California to do some family research. After a day in the files in the Carnegie Library, he

Stairs to the basement of the Gray Brothers building, where Ridge kept his barbershop. Guests have been known to trip as if an unseen foot has reached out for them.

returned to his room in the Pollard Inn. He was working at his laptop at the desk when he suddenly got the chills.

On the bed across the room, a strange indentation settled onto the covers. It was like someone big was sitting there, but no one was to be seen. Then came the familiar smell of cigar smoke. When he described the strange event to Brown later, she pointed out that his room would have been Ridge's old apartment.

One Guthrian reminiscing about Ridge and pondering his spirit described him as not an evil or even very bad man, "just kind of mean." She believed that "he's stuck," unable or unwilling to cross over, instead preferring to continue hanging out amid cigar smoke and pulling a few tricks now and again for his own amusement.

CHAPTER 12
CAN YOU FIND ME?

STONE LION INN

While some owners of haunted buildings don't like the idea of word spreading about their ghosts, others revel in the history and the unknown. Such is the case with the Stone Lion Inn, one of the most famous haunted sites in Oklahoma. Becky Luker, who bought the home in 1986, transformed it into a bed-and-breakfast where guests eager for a ghostly encounter might very well have one.

The large, white Victorian house on West Warner was built in 1907 by F.E. Houghton. He came to Guthrie with the Land Run of 1889 after his first wife and son passed away. With one daughter surviving, he married nineteen-year-old Bertha, and they had twelve more children. To house such an army (let alone feed them), Houghton had to work hard to build up his business. It paid off when he cofounded the Houghton & Douglass Cotton Company in 1903. The large factory on the banks of Cottonwood Creek produced valuable cotton oil, which was sold all over the nation. Four years later, Houghton started construction on his eight-thousand-square-foot home that would cost $11,900, ten times what houses usually cost.

The Houghton Mansion was not just a place to live; it became a center for the elites of Guthrie. A wide porch surrounds the house, even extending to a covered carriage port where guests to parties were invited in. The first floor with its gentlemen's smoking room and elegant

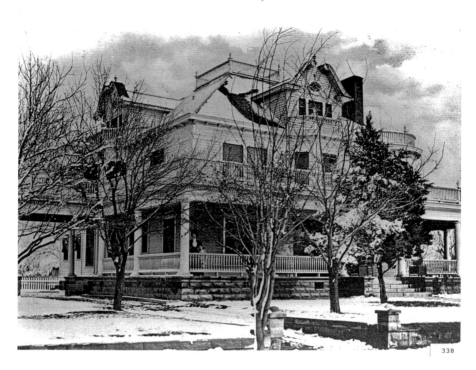

An old image of the Houghton Mansion shows it much the same as today. *Courtesy Bob Bozarth Photography.*

parlor are built with shining golden oak. The family's rooms upstairs were made of more humble white pine, but there was still plenty of more intimate entertaining to do in the third-floor ballroom, which was a very popular asset in the mansions of the wealthy in early Oklahoma. As more and more kids came into the family, it was eventually turned into a playroom.

Houghton's fortunes changed as the factories in Guthrie began to wane, and the family moved on, many of them to Enid. The house became a funeral parlor, and its immense basement became a mortuary. Later, the former mansion was turned into a boardinghouse, and then it came into Becky Luker's hands. She set about a project transforming it into a bed-and-breakfast, doing heavy renovations such as installing indoor bathrooms upstairs.

During the remodeling, Luker and her sons lived on the third floor while work crews lived in other rooms. She awoke to the sounds of footsteps and doors opening in the middle of the night, but she thought nothing of it with

so many people in the house. The remodeling finished, and the workers moved out, but the sounds continued.

Luker was hardly worried by any superstition. When they found a huge, beautiful white stone table in the basement, she brought it up to the hall to be used for buffets. Later, she was told that it was, in fact, the embalming table from the house's stint as a funeral home. Instead of being upset, Luker was even more excited by the find. Just the same as the noises at night, the table was part of the charm of the old mansion.

Soon the story became more than just sounds. Luker's younger son began complaining about someone messing with his toys. He would fastidiously put them away in his closet when he was done playing for the day, but when he opened it up the next morning, the toys would be rearranged as if someone else had been playing with them. Sometimes, the toys would have even left the closet and lay scattered over his bedroom floor. Luker put a padlock on the closet door to settle his worries. Yet behind the locked door, the toys still moved around.

Eventually, Luker's son became friends with his ghost. He began asking the housekeeper, Michelle, to make up extra snacks for the little girl who lived in his closet. The Lukers moved out in 1996, but guests to this day have tales of strange experiences in the night.

The most common claim is to hear footsteps, giggling or doors opening and closing. A few guests say that they have in fact been touched by the spirit. Sleeping cozily in their rooms, they'll wake up to small unseen hands patting their cheeks or stroking their hair. Some have even said that they slept unknowingly through the little girl's playing and woke up to find their hair braided.

The legend of the origin of the little girl involves one of Houghton's daughters, Augusta. A few months after Luker moved in, one of Houghton's sons, Russell, dropped by to see the house. He said that his sister Augusta passed away there in 1910 from whooping cough at the age of eight. The story goes that she was very sick, and the medicine she was given was made from opium. As the illness worsened, the little girl took more medicine, eventually overdosing.

Paranormal researchers called the story into question after looking at census records for Guthrie. Coralee Augusta actually appears in the regular 1900 census, listed as being born in 1892. She would have been eighteen in 1910 rather than eight. Instead of dying of whooping cough then, she was actually in Wichita, attending Mt. Caramel Academy. She married William Houser three years later and lived a long life.

Some say that Russell may just have been pulling someone's leg, but further research turns up another curious mystery. In the 1910 census, the same one in which Russell appears born 1908, there is a Houghton infant named Irene listed as "0 years old." Despite further research, no one has found anything more about Irene. Perhaps Russell misremembered stories he was told from when he was two years old, and a different Houghton sister is in fact the ghost.

Skeptics of that theory point out the ghost is clearly a child, not an infant. Much debate carries on in the paranormal investigation community, with still others offering theories from the house's century of history or simply a wandering spirit who was happy to find a closet full of toys to play with. Whatever the identity of the mysterious ghost girl may be, there is certainly activity in the house. Everyone who has spent enough time there has a story.

Some of the eeriest stories center on the nursery room, which is attached to one of the bigger suites upstairs. The little girl has been seen there time and again, playing with the dolls in the crib. One guest recalled being spooked by the dolls' wide eyes, so she covered them up with a blanket. She woke up in the night to find the blanket had fallen off them. They still made her too nervous to sleep, so she got up and moved the dolls into the closet. When she woke up again, the dolls were carefully arranged back in the crib. This time she left them.

The famed paranormal investigators from the *Ghost Hunters* television show spent a night in the inn during its second season. They discovered a number of electromagnetic fluctuations, said to be the telltale sign of spectral activity, but this skeptical approach determined they were more likely caused by old wiring. Yet

Dolls rest in the nursery's crib.

the physical evidence proved more shocking: one investigator felt someone brush by her, and another heard a voice call out.

When asked whether she had any experiences herself in the house, Michelle started laughing. "Oh, I've heard all kinds of things," she replied.

On at least two occasions, she went into the basement and came back up to find the deadbolt in the door locked behind her, even though she was the only living soul in the house. It is certainly a childish prank with no real harm done—something a little girl might do for laughs.

A second ghost is said to wander the Stone Lion Inn. He has been described as a middle-aged man in a gray suit with a bowler hat. Some say that it is Mr. Houghton returning to take a look at what has been done with his home; the smell of his cigars sometimes arises in the living room. Others say that it is a man called Edward who came to the house for services during its time as the funeral home.

Just as playful as the little girl, the older man seems to enjoy giving people a scare. He has been known to appear in mirrors just over peoples' shoulders. When they turn, he is gone, leaving the victim of his joke

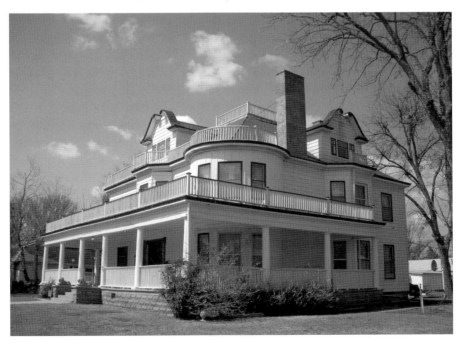

Renovated to its former glory, the Houghton Mansion now hosts the Stone Lion Inn.

gasping in fright. One paranormal investigator claimed that he spoke to her, literally calling out, "Boo!"

The ghosts of the Stone Lion Inn seem eager to interact with the living. Neither of them has ever been accused of hurting anyone, although there are a number of occasions when a terrified guest has run out of his or her room screaming loudly enough to wake the whole house.

BROTHERHOOD

SCOTTISH RITE MASONIC TEMPLE

Perhaps one of the most iconic views of Guthrie is looking down Oklahoma Avenue toward the sprawling, columned gray stone Scottish Rite Masonic Temple that rests in the center of Capital Park. It is a massive structure of more than 400,000 square feet with huge two-story halls and its capacious auditorium, as well as smaller meeting rooms and, according to some, a few hidden chambers only the entrusted few know. The complex history brings together some of Guthrie's most disparate yet influential parties: state legislators, higher education and the Masons.

Capital Park had been set aside in Guthrie shortly after the Land Run of 1889. The federal organization of the Oklahoma District and then the whole Oklahoma Territory proclaimed Guthrie as the official capital, and the city was eager to please its lawmaking guests. In the early days, there were a few offices for administrators, such as the federally selected territorial governors. All that changed in 1906, when the Enabling Act authorized a convention to pound out a constitution that would merge Oklahoma Territory, Indian Territory and the Panhandle into a single state. On June 6, 112 delegates came to Guthrie, 99 of them Democrats, with the Republican "twelve apostles" and one "renegade" independent, as recorded on the convention roll. William H. Murray presided (later becoming the legislature's first Speaker of the House and Oklahoma's ninth governor) over a convention

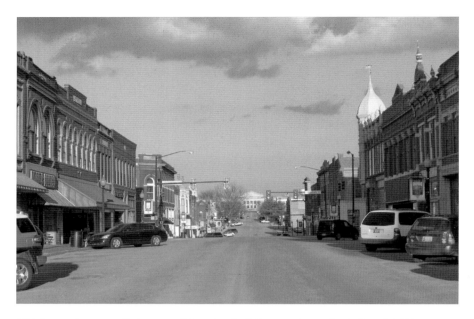

Oklahoma Avenue rolls between Victorian buildings to the majestic Scottish Rite Masonic Temple.

that included three more future governors and James Buchanan, fourth president of the University of Oklahoma.

The convention met in Brooks Opera House, as the territorial legislature had never put together the funding for a capitol building. Guthrie was keen to have one, since the Enabling Act obliged the city to remain the capital only until 1913, and a permanent state capitol would serve as an anchor to keep politicians there. Boosters for the city like *State Capital* editor Frank Greer called for the city to build such a structure since the legislature hadn't, even though the land in Capital Park had been available for years. A $150,000 bond was raised in 1905 ($3.9 billion today), and the eastern portion of Capital Park became the site of Convention Hall in 1908.

This new building was a shining example of modern construction on the prairie. Postcards showed its sweeping, rounded copper roof standing between twin brownstone wings. The legislature begrudgingly met in the shining new halls, but Governor Charles N. Haskell kept his offices in the Logan County Courthouse, where his secretary "accidentally" left a bundle of laundry that smuggled out the state seal. Inside the very walls that the city of Guthrie had paid to build, the legislature passed a bill to put the state capital to a vote, a vote Oklahoma City won by a wide margin.

With the governor and the legislators moving to Oklahoma City, Guthrie was caught with a massive empty meeting space. It quickly found a new purpose for the old Convention Hall, as well as a chance for Guthrie to catch up to cities like Norman and Edmond in higher education. Capital Park was offered to be the new site for Epworth University.

Epworth began as a unified institution for higher learning in 1903 between two branches of the Methodist Episcopal Church. The original campus for Epworth was near Classen and Northwest Eighteenth Streets in Oklahoma City, near the Epworth United Methodist Church and where the Classen School of Advanced Studies is today. Epworth University came to Guthrie for new, expanded facilities, as well as a boost of $100,000 from Gurthrians into its endowment.

Epworth wasn't the first institute of higher education to come to Guthrie. In 1890, the territorial legislature put together bills for schools in the new territory: Oklahoma Territorial Agricultural and Mechanical College (known as OSU today), Territorial Normal School (UCO) and Norman Territorial University (OU). Guthrie, along with Kingfisher and others, put a bid out for the Territorial University, but Norman's citizens won the school with a large land grant southwest of town. While Norman was still working to get faculty and classes together, however, an enterprising Guthrian by the name of William Albert Buxton determined to go the way of for-profit education and founded his own Oklahoma University.

Buxton was no stranger to education; he had been schooled in New England and done his graduate study at the University of Heidelberg in Germany. He had taught as well as preached, and now he sought to found a university with himself as president and professor. With his brother's life savings of $10,000 and the support of the Guthrie Board of Trade, Buxton bought land at the corner of Broad Street and Harrison Avenue and constructed a two-story brick building. By spring of 1892, Buxton had busily advertised the new school as opening that September in the new Buxton Hall. His building was to be packed with classes offered at every level from kindergarten to high school on up to liberal arts, graduate study and "professional programs in law, pharmacy, dentistry, and medicine"—anything a student could want and was able to pay for.

The territorial superintendent's list of schools in 1892 actually counts "Oklahoma University, Guthrie" as having 150 students, the most of any in the list. Second was Oklahoma College and Business Institute with 130 students in Frisco (which became a ghost town in 1904 between Fort Reno

and Oklahoma City). Public schools in Norman, Stillwater and Edmond had seventy to eighty students apiece.

While much of the attention for the start-up school was good, Buxton's request for sample textbooks from a publisher in Topeka, Kansas, brought the federal marshals to his door. The publisher determined that Buxton was attempting to usurp the University of Oklahoma in Norman, which also was starting classes that September. This constituted an accusation of mail fraud, which sent marshals down to investigate. Eventually the case was thrown out, but Buxton had all of his money tied up in the school, meaning he had to wait long days in the new federal jail through the late summer and into the fall. Without its president, the school struggled.

By 1893, what had become known as "Buxton University" for clarity was routinely printed in the *Leader* and *State Capital* as a troubling issue for the Board of Trade, which was still owed much money by Buxton. The once-professor left town, and the university building fell into city ownership. It continued in use with rooms leased to Guthrie public schools and a private kindergarten under Mrs. E.G. Hogan. A Methodist pastor, Joel F. Smith, continued Oklahoma University with some of the former faculty in 1893, but the mail fraud scandal had been a deathblow. The Board of

Originally the site of Oklahoma University's Buxton Building, the Logan County Courthouse saw the departure of the state seal one night in 1910.

Trade finally sold the building for $1,000, and the territorial legislature held sessions there. In 1907, as the legislature left for Convention Hall, the Buxton University Building was torn down and replaced with the current Logan County Court House.

Fifteen years later, Guthrie was once again a center of higher learning. Taking Epworth from Oklahoma City must have been all the sweeter as a bit of payback for the loss of the capital. Yet once again, the school would change places. By 1916, the great plans Guthrie had laid for the expansion of Epworth had not become a reality. As businesses moved out of Guthrie, money became harder to find, and so educational commissioner Reverend W.D. Parrish began hinting at a move back to Oklahoma City.

It only became worse. With the Spanish flu and poor crops, class sizes dropped to only a few who were willing to risk public space and were able to pay. Legal battles began over mortgages and endowments, and in 1918, the university went up for auction along with old Convention Hall and the acreage Guthrie had granted it. Ultimately, the remainder of Epworth that was defended by the Supreme Court returned to Oklahoma City, reinvigorated by the Methodist Church and later renamed Oklahoma City University.

But the experiment was not a total loss. The land was bought by the Scottish Rite Masons of Guthrie, who had outgrown their original lodge at the northeast corner of Harrison and Broad, just across the street from Buxton's University Building. The Masons seized the opportunity to expand as well as contribute to Guthrie, which had served as a focal point for Oklahoma Masons since the very beginning.

Thousands of people made the Run of 1889, and the large majority of those thousands were male. Wives and children usually came after the Run, but there was still a surplus of men who needed to interact socially. McGuire's *Birth of Guthrie* speaks of "brotherhoods" founded the very first night among the campfires on the prairie. These brotherhoods came from many different fraternities, some organized and some more good-humored, but the Ancient and Accepted Scottish Rite of Freemasonry won out as the largest.

One of those who made the Run was Harper Samuel Cunningham, a thirty-third-degree Mason, who soon set up a law practice in the new capital. Legend says that Albert Pike himself appointed Cunningham to the quest of building the Mason brotherhood in the new territory. Pike, who died in 1891 and had served as sovereign grand commander of the Southern Scottish Rite since 1859, knew a good deal about expanding the brotherhood. He

had literally written the book on it in 1871: *Morals and Dogma of the Ancient and Accepted Scottish Rite of Freemasonry*.

Cunningham led the fraternity in town, which bolstered enough numbers to found a Lodge of Perfection in 1896. There were plenty of connections with Guthrie and the Masons; Judge John Guthrie himself was thirty-third degree. As more members joined and others in Oklahoma Territory looked to Guthrie as the center for Freemasonry, a Consistory of Princes of the Royal Secret was added for the utmost degrees. In 1919, the order was ready to add a new temple to be the focal point of Masons in the whole state of Oklahoma. It only seemed fitting that Guthrie would serve as a capital of sorts, even if not for politics.

The new temple was completed in 1923. It was attached to the standing convention hall, which now rests in the shadow of the enormous Classical Revival forefront. Artists from Europe had been brought over to decorate the marble, gray stone and plaster. To this day, the walls are covered in mysterious symbols that may seem like ornaments to the uninitiated, but they silently whisper codes to Masons in the know. It has served the city for decades, renting out space on the weekends for everything from local proms to national talent searches. In 1987, the temple was noted on the National Register of Historic Places as "the largest, most elaborately designed and constructed Masonic Temple in the state."

While there are many rumors about the living inside the temple, with its many alleged secrets, there are ample ghost stories that everyone seems willing to share. Doors open and close themselves, and footsteps ring on the marble floors. With as many different sets of shoes as have trod there, from early state legislators to Methodist students to generations of Masons, one can easily imagine that a few of them have come back to visit.

Among the most fun stories is that of the billiards room, where several people have claimed to hear pool balls clatter. One young Mason told about the time he was walking past and heard the familiar clack of a cue in a skillful shot. When he hurried inside to see who was playing, he found the room empty, except for the balls spread out on the table in mid-game. A few have gone as far as to say that they have seen the cues move on their own. Others don't think much of the ghosts, outside of blaming a shot gone wrong on spectral interference.

One of the most famous ghost stories about the temple, often recounted on Stacey Frazier's ghost walks, is the story of the mysterious woman who appeared in a theater scene filmed in the auditorium for the 2010 adaptation of the Jim Thompson novel *The Killer Inside Me*. Guthrie has hosted numerous

The Scottish Rite Masonic Temple dominates what was once intended to be Oklahoma's state capitol grounds.

films, such as *Twister*, *Public Enemies* and *Rain Man*, and no one expected anything out of the ordinary this time around. The crew had no problems during the shoot, and many Guthrians were happy to act as extras. Yet when Katherine, one of the post-production assistants, began to compare the faces in the camera shots with everyone's signatures in the releases, she came across a woman who wasn't supposed to be there.

Katherine compared the notes over and over again and even searched for someone who could have let a woman into the shot without getting a release. No one knew anything, especially how the woman got on set in a costume out of the 1930s when the film was to take place in 1952. Yet there the woman sat in her print dress and bob hat. Strangest of all, there was something familiar about the woman, as if Katherine should have been able to place her. The shots with the mysterious woman eventually had to end up on the cutting room floor, and the movie went on without her.

That fall, Katherine came home for Thanksgiving, where she had long talks with her grandmother, who was proud to have a descendent in the film industry. The grandmother talked on and on about how movies were so much a part of her life in the Great Depression. As young women, she and her sister Kathy would go together to see all the greats of the Golden Age of Hollywood. Their time together ended too soon when Kathy passed away,

only in her twenties. Katherine was surprised to hear her grandmother talk about her great-aunt Kathy. Even though Katherine served as her namesake, she admitted, "I don't think I've ever even seen a picture of her!"

Her grandmother obliged, and they dug together in old family photos until they found a picture of Kathy before she died. Katherine was shocked. It was the woman in the film from the temple auditorium, wearing the same outfit and the same hat.

CHAPTER 14

SPIRITS OF CHARITY

THE MASONIC HOMES

Abandoned buildings are a constant reminder of what once was. Even with a relatively short state history, the Sooner spirit has started many projects in Oklahoma that would later move on to leave a shell behind. Guthrie, with its early lead as the territorial capital and then first state capital, has seen its own widespread collection of deserted buildings.

Despite losing the capital and even its prospect into higher education at Epworth University, the city found its longtime friendship with the Masons to be a boon in the midst of struggle. As World War I came to a close, Oklahoma found itself in a strong commercial position. Europe was rebuilding, so food and oil prices were high as a benefit to farmers. Although factories left the city, Guthrie was seen by the charitable spirit of the Masons as a land of opportunity. This would be the site for two of their greatest charities, which would soon become two of Oklahoma's most famous abandoned buildings: the Children's Home and the Home for the Aged.

The Grand Lodge of Oklahoma united on February 10, 1909, from the two territorial Grand Lodges that existed before statehood. With endowments running some $50,000 ($1.3 billion today), the Grand Lodge Masons were eager to use the money to support those who needed help in the new land. As early as the turn of the century, funds began specifically for the Home for Widows and Orphans. A temporary location for the home

The Masonic Grand Lodge is another branch of the brotherhood in Guthrie.

was offered in Atoka, and then the brotherhood purchased the Darlington Agency, once part of the Cheyenne-Arapaho reservation, from the federal government. The home continued there for a decade, with dormitories for boys and girls and cottages where elder Masons could retire.

While Darlington was successful, Grand Master O. Lonzo Conner raised the question of building a separate Home for the Aged in 1919. At the same time, the Scottish Rite Consistory of Guthrie purchased the old Epworth campus and had room to spare. A deal was struck between the two branches of Masons to donate land north of town, and the Grand Lodge voted overwhelmingly to move the home to Guthrie. In 1922, the Guthrie Children's Home was established, and Darlington was sold to the state to become an addiction clinic. The transfer was completed in 1944, when even the Masonic cemetery in Darlington was transported to Guthrie.

By 1925, the home in Guthrie was already feeling growing pains. Even though it was the Children's Home, it also served the elderly who needed a place to live out their final years. Grand Master Henry S. Johnston called for a separate Home for the Aged, saying, "The old people must be gotten out of the Home. Elderly men smoke and chew and swear and elderly men and elderly women both grouch and complain, and the very playfulness which makes a boy the delight of a parent, the sunbeam of a home, renders him an

object of aversion to some elderly persons who are not related to the boy or interested in him, especially when his noise and play clashes with their past habits of life or the condition of nerves of the elderly."

His brothers agreed, and work on the Masonic Home for the Aged began in 1926. The site was again Scottish Rite land, just west of the Temple on Ash Street. It stood some six stories tall, housing eighty-eight senior citizens by 1931. In 1955, the Masons expanded further with a four-story annex while constructing the new Grand Lodge building nearby. After almost fifty years in service, the Home for the Aged was moved to a modern facility out on West Noble in Guthrie. With services

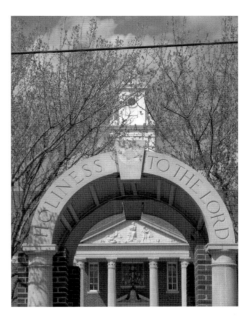

Masonic emblems and messages still stand on the revitalized Dominion House.

moving out, the building was donated to Logan County in 1995.

There it has stood ever since.

The old Home for the Aged is an eye-catching monolith on the east side of downtown. Although it is breathtaking, the building is part of the Historic District, which makes doing a renovation difficult and costly. Instead, the tower merely stands with chipping paint and boarded-up windows.

With the Logan County Courthouse just across the street, the Home for the Aged is largely safe from vandalism. Urban explorers and a few ghost hunters have claimed to have investigated inside the building. It is surprisingly tidy for its forty years of abandonment, dusty in corners but largely in good condition. Discarded furniture, boxes of old books and even old tins of food are strewn throughout. Each floor is a like a place frozen in time, with bedrooms, kitchens, common rooms and hallways much in the same condition as when the doors were locked up in 1978.

It is uncanny to see how differently the rooms have aged. Some look like disasters with cracked walls and rusted pipes. Others seem as if someone has just stepped out of them, the little piles of dust swept into the corner. The old home is used for storage, but many of the rooms stand empty, except for

Empty for forty years, the Masonic Home for the Aged once housed hundreds of people in their final years.

what was already there. It is almost as if the old caretakers are still at work, despite having passed away decades ago.

There are many legends about the ghostly goings-on in the Home for the Aged. Some say that a few of the old clients remain in the building, wandering the halls. Time and again, people have said they saw people walk from one window to the next. County workers who go into the building to retrieve items from storage don't claim any specific ghost stories, but they do admit they don't like to go in there.

The Children's Home far to the north has its own colorful history and an even larger collection of ghost stories. In 1927, as the aged moved to their new home, the Children's Home was occupied solely by staff and by kids who were orphaned or turned over to the custody of the state. By 1930, there were over 118 children living there. As the Great Depression wore on, the future for the children there looked more grim, and the Masons began giving vocational training. Royal Arch Masons established an entire Vocational Building on the grounds in 1936.

Renovations are prepared on the old Masonic Home for the Aged.

One of the major benefactors of the Children's Home, as well as numerous other charities in Guthrie, was Oklahoma oilman Lew Wentz. Growing up in Pittsburgh as one of seven children of a blacksmith in the days when mass production wore a blacksmith's chances for employment thin, Wentz knew poverty. Unable to afford college, he worked as a baseball coach, the first of many fields in which Wentz's keen mind found success. Wentz is credited with revolutionizing the position of umpire, having them dress in black and give signals with the right hand for strikes and left hand for outs. In 1911, thirty-four-year-old Wentz arrived as a secretary to Ponca City to manage oil ventures. Soon he began his own oil company, making an enormous fortune as automobiles soared in popularity in the 1920s. By the time he retired from the oil business, his leases were generating a personal income of $1 million per month. He never married, and he used his fortune for charity work: personally handing out toys at Christmas, renting out entire circuses and movie shows and donating land in Ponca to the Boy Scouts for Wentz Camp with its famous "castle" swimming pool resting under two Romanesque

towers. Wentz's legacy lives on to this day in scholarships and in Guthrie with a street renamed for him between Division and Broad.

After a long legacy of charity, life at the Children's Home changed in 1974 alongside changes to the state foster care system. The Oklahoma government sought to establish more family environments for children rather than sending them to orphanages like the Children's Home. After all the youngsters placed there by the state were pulled out, only ten children were left. By 1978, there were only three, and the home closed.

For many years, the old home sat empty. It became a particular favorite among teenagers and thrill-seekers. There were numerous routes to sneak over fences, across the overgrown grounds and into the towering old dormitory. Inside, walls stood covered in spray-painted tags, items left behind were looted as souvenirs and people told ghost stories.

Several stories developed about the supposedly cruel staff members who oversaw the hapless children. One housemother was said to be so strict that children were afraid to speak at all, walking silently through the halls as if in a daze. Another rumor spread that her reaction to any misstep was corporal punishment; when she beat a child so hard that he died, she simply buried him in the basement.

Dominion House, the former Masonic Children's Home.

They say that one of her aides was so broken by the severe treatment of children that she hanged herself in the clock tower. A different story tells the tale of an unfortunate groundskeeper, who, after years of bad luck, hanged himself there. Both stories agree that, usually at midnight, a ghostly form would relive the final moments of hanging by the neck from the tower, and people brave enough to sneak inside could see.

Despite all of the stories, many neighbors to the old Children's Home say that they haven't heard anything out of the ordinary. A few Guthrians have ventured to say that they have heard the sounds of running feet at play, and laughter from children sounded at night and even during the day, although the building long stood empty. Others remained skeptical, especially after the remodeling cleaned up the old Children's Home.

In 2000, the building was purchased by the Burgesses and renovated into a venue for celebrations. Now the Dominion House, the former orphanage serves as a luxurious setting for weddings, anniversaries and office parties. The indoor pool has been turned into a chapel, the grounds landscaped and the whole building given a facelift. Numerous people have had their ceremonies there, and no one seems to have spooky stories to tell.

Yet others pass on the rumors of old, saying that some spirits of the past still linger, fastidious against even complete renovations. At least the sounds of laughter and kids playing are a more encouraging thing to hear than the rumors of twisted cruelties to the children. In fact, some say that the ghost of a little boy often appears at the weddings. When he does, it's considered good luck for the new couple.

CHAPTE 15

TAFFETA

EXTRA SPECIAL FABRIC STORE

The F.O. Lutz Building, which is perhaps more famously known as the Lintz Department Store, has been serving the home goods customers of Guthrie for over a century. The building began as a two-story edifice in 1899, stretching across two joined lots to form the Grand Leader store founded by Hirsch and Kauffman. The *Daily Leader* lauded it as the "leading store in the territory," befitting its name. It had an extensive floor with clothes, pans and dishes, early appliances and anything a territorial household could need. Storerooms kept extra stock in the back, and offices for accountants and managers could be reached through the rear alley by a set of indoor stairs.

In 1904, F.O. Lutz came to Guthrie. Lutz had started his mercantile career as a traveling salesman for the Wholesale Dry Goods Company in Kansas City, Missouri. After a few years on the road, he determined he could make more money working with the customers instead of serving as middleman from the supplier. He founded one store and then another and still more in the northern part of Kansas. With the economy surging in Oklahoma Territory and the initial wildness settled for over a decade, Lutz decided his next step would be into the capital city of the bustling new community.

Lutz bought up the Grand Leader from Hirsch and Kauffman with an immense amount of business capital built up from his other stores. He kept on the staff and closed up shop for just a few days to take stock and plan his

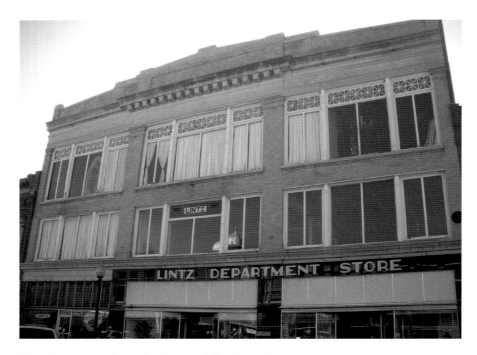

Lintz Department Store after its remodeling into a three-story structure.

reopening. The Grand Leader exploded back into the market at the start of September with a sale that brought in crowds from around the county and beyond. Lutz planned to sell off his whole stock in two weeks to make room for new items of his own selection for the fall.

Business was good. Always looking to expand his business ventures, Lutz brought in Fred W. Lintz, another traveling salesman for Wholesale Dry Goods whom he had met years before, to serve as a partner. In 1909, the store again took a sabbatical from business to expand, this time in a major construction boom. The building to the east was bought up and joined with the Lutz Department Store, and a third story was added to tie the whole structure together. In the 1920s, the original two-lot storefront was marked off with black Carrera glass, showing how much the store had grown.

After Lutz's death, his widow gradually sold her stock to Lintz, who attached his own name to the department store as the state struggled through the Great Depression. Lintz was as much of a businessman as Lutz, and he began gathering his own partners to expand when the Depression began to end. Lintz Department Stores soon popped up in Pauls Valley, Perry and

down into Texas. Eventually, the chain set up corporate offices in Dallas and operated for over seventy-five years. The chain was famously the "Stores of Smiling Service," and Guthrie was the jewel in its crown.

Over the years, enormous supercenters and big-box markets outpaced the small-town store, and today much of the Lintz Department Store in Guthrie is used as storage. The corner of the building incorporated in the 1909 remodel, however, hosts the bustling Extra Special Fabric store. It specializes in western patterns, and the walls are lined with bolts of cloth bearing proud horses, sunsets on the plains and plenty of cowboys. Other specialty patterns give crafty sewers the chance to make blankets, pillows or just about anything from cloth touting their favorite college, soda pop or tractor brand.

Owner Laurah Kilbourn moved Extra Special Fabric from the Gray Brothers building in 2006, partially to get away from a pesky spirit there that knocked things off shelves and gave off a strong aroma of cigar smoke. While her shop is no longer haunted by cigars, Kilbourn did once more set up in a store with a ghost.

Elsie is said to enjoy the decorative baby carriage.

Time and again, especially in the early days of opening at the new location, she has come into the store to find various spools or things on the counter knocked to the floor. Other times, items in the store would be swapped, as if someone had gone through them overnight and decided there was a better way to set up displays. With the doors locked and the security system enabled when Kilbourn closed up, however, she doubted anyone living would sneak into the store just to rearrange.

While the strange events at nighttime went unexplained, there were also peculiar sounds all through the day. The old wooden floors creaked, first in one place, then another and yet another farther down, as if something was crossing the room. There was also an oddly familiar "swish, swish" noise that sounded so often that Kilbourn brought in a handyman to take a look at the ventilation system. Everything checked out in the air conditioner and heater, which was just as well since the swishing would happen even when the air wasn't turned on.

Initially, Kilbourn didn't think too much of the strange events since the building was more than a century old and was bound to have its eccentricities, but her curiosity was piqued when customers began reporting odd experiences of their own. Many people who came into the shop shared a constant sensation of being watched, the prickling of hair on arms and necks or the pressure of an unseen presence. Some noted watching shadows move in the room even when there was nothing in front of the light.

Others also described the "swish, swish" sounds. A patron immediately recognized the sound as skirts made of taffeta, the fabric made from a mixture of silk and rayon. Still seen today in formal dresses, taffeta was once very popular for even everyday clothes among classy ladies. An older relative of hers had worn her taffeta practically religiously, and the particular sound still stood out in her memory.

The mysteries came together when a customer who described herself as psychic stopped into the shop, paused and announced that there was, in fact, a spirit living in the store. She said that the spirit was named Elsie, and she enjoyed the baby buggy set up on display, as well as the big pink easy chair placed in the front of the store, where she apparently spends much of her time sitting. Digging back into the records of the Lutz and Lintz stores, it seems there was an Elsie employed as a seamstress. Apparently she had come back to continue her work in fabrics.

Kilbourn says that, even to this day, every once in a while, she will come in to see something on the floor. Some speculate that it is Elsie throwing a fit to show that things are not where they should be, but Kilbourn says that

Guests who sit in Elsie's pink chair are said to have a creeping feeling of being watched.

she hasn't sensed any hostility. In fact, she said that one of her psychic customers told her that Elsie likes the shop just fine and may simply be trying to help out.

As if one spectral former worker wasn't enough, a second ghost haunts the rear of the Extra Special Fabric store. Kilbourn and her staff first noticed him when they heard someone walk up the back stairs as they came into the shop early in the morning through the back door. Thinking a vagrant had gotten into the building, men were called in to investigate, but there was nobody to be found on the mezzanine or rooms upstairs. Even so, morning after morning, footfalls could be heard thudding up the stairs. They eventually decided the stairs must have been creaking as the building settled in the morning.

Yet two startled customers did, in fact, see someone. On separate occasions, the customer was in the back looking at the store's extended collection when a full-bodied apparition appeared and disappeared. They described the man as wearing a red shirt and overalls. He looked very sickly, and he moved on as quickly as they blinked.

Further psychic investigation determined the man's name to be Joel. Department store records list an employee by that name who served as bookkeeper. The accounting offices were upstairs, connected by the mezzanine to the same stairs that now creaked early each morning. The dedicated bookkeeper apparently is still hurrying in to work, not even letting death get in the way of a daily routine.

CHAPTER 16

THE HOMEFRONT

AMERICAN LEGION HALL

Located one block north of the historic downtown district in Guthrie is the American Legion Hall. Founded in 1919 by Theodore Roosevelt Jr., the American Legion is an association for veterans from all branches of service. There are numerous halls for the American Legion across the nation, and Guthrie is no different.

Home to a wonderful group of volunteers, this building consists of a large upstairs area with a full kitchen available to host weddings and events. Downstairs consists of a smaller meeting room and what is known as the Young Marines Room. Prior to it belonging to the American Legion, the building once housed a large laundry service.

We were first introduced to the American Legion when we were looking for a venue to hold our Halloween event, and one of our friends suggested the Legion Hall. Dee and I decided to take a look, and the moment we arrived, we simply looked at each other. Not only was it a suitable venue, but it also felt haunted.

As we were being shown around the building, we came the Young Marines Room. When our guide opened the double doors to the room, a gust of wind blew from it into our faces in the hall. It held a whole mixture of emotions: anxiety, anger and fear. Dee became overwhelmed, feeling upset and ill, and had to excuse herself to step outside.

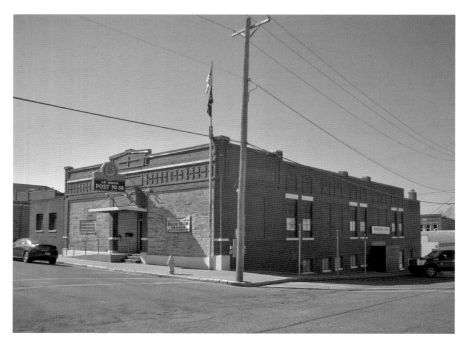

The American Legion Hall hosts community get-togethers and soldiers of bygone eras.

Needless to say, we booked the venue that day.

For nine months, we have been investigating the American Legion Hall and received several different pieces of evidence. The Young Marines Room has proven very active. What appear to be several different entities came forward for us, and the activity increased as the months went by. The first entity that decided to show himself did so while we were setting up for our Halloween event. The sun had not even begun to set when I turned to see a tall, slender man about six feet in height standing in the doorway. He was dressed in what appeared to be an all-white officer's uniform. He stood there with his arms at his sides staring straight at me. There were no other men in the building with us, and it was locked. I remember standing there, wondering if I had actually seen what I thought I saw, when my nine-year-old daughter turned to me and asked, "Mom, did you just see that man standing there?" He was only the first of many we would soon be encountering.

Another entity that is often felt is one who goes by the name of P.F. Adams. He usually appears in the Young Marines Room and likes to interact with Greg, one of the men from the Legion, becoming much more active when

he is around. The entity seems to be very shy, not liking large groups of people. Others tend to be more vocal with more people around, such as one that came forward more recently.

A group of us were gathered in the Young Marines Room for an investigation. At first, it seemed quiet, and then the ghost radio started talking. We knew we were dealing with what seemed to be a young man. When near spirits, we often are shown images that come across like movies in our mind, a way for them to show what they want us to know. I asked him to please show himself to me. He appeared as a military man in full uniform.

Suddenly I felt a pain in my chest. I felt like I was no longer in the room. I looked down at my chest to see my hands holding an old-style bandage with cloth ties hanging down. When I pulled the bandage away, I saw blood and multiple small wounds. I felt multiple areas of my chest burning, like I was pressed against hot metal. I looked up to see tall green grass bending to the wind from an army helicopter. Men were running everywhere as I heard several voices yelling out, "Medic!" I knew then that this soldier was showing me some of the last moments of his life.

He was young, no more than mid-twenties. The ghost radio started saying words like "bandage" and "heart." As I was describing the pain in my chest to others, I said it felt as if I had been shot in the heart. I sensed the entity pacing between the closet and the other side of the room, walking directly behind me. Others in the room reported seeing what appeared to be a shadow figure moving back and forth. We could all feel the change of temperature as the spirit continued to pace. Another shadow blocked out the doorway to the closet. One of our investigators aimed her camera toward the closet and took three pictures. In one of the pictures, the outline of a tall, dark figure stands with what appears to be a backpack strapped to his back. None of our group was standing, so we know there was no way any of us could possibly cast the shadow, especially since the only light in the room was from the flash of the camera. The entity's name is still unknown to us.

Another spirit that is often seen and felt at the American Legion Hall is that of a woman. She appears to be from an earlier time period. She is often seen in a long, Victorian-style dress with a high collar. She claims to be a worker from the time when the building was once a laundry service. There also appears to be a little boy who likes to hang out and watch. While investigating in the Young Marines Room, we detected him with the FLIR gun, sitting at the top of one of the walls. There were no shelves for him to sit on; he was just there, floating. It is possibly one of the strangest images we have caught to date.

Other activity has also been witnessed throughout the building. While investigating in the Young Marines Room, we have heard very distinct footsteps, the sounds of multiple people walking about. Even when no one is up there, the grinding of furniture being scooted across the floor rumbles. Shadows wander about the upstairs event room, and noises have been heard in the kitchen area. It appears that while the American Legion may host many parties and events throughout the day, it also hosts the spirits of the night.

Like many of the buildings we investigate, we were unable to locate any history of deaths on the property. Of course, a death does not have to occur on site for a building to be haunted. The land may hold a connection with spirits of the past, or objects can be brought in that have an attachment. In the Young Marines Room, the closet is filled with knapsacks once used by soldiers. Could the energy and emotions once felt by these young soldiers remain in these objects, giving them a portal back to our world to tell their stories of defending our country?

CHAPTER 17

HOSPITAL ON THE HILL

LOGAN COUNTY HOSPITAL

A red-brick tower stands looming over Guthrie, visible wherever trees and rooftops are clear. The hilltop hospital may once have been meant as a beacon of hope, but now it is an eye-catching, seemingly sinister pylon that has been known to give visitors to Guthrie shivers. Locals, many of whom were born in that very hospital, feel no more than a little nostalgia, although many agree that it is clearly haunted.

The hospital has been known by many different names through its long career. Construction began in 1925 for a new Methodist Episcopal hospital, but funds ran out before it could be completed. In 1932, construction resumed on the newly renamed Cimarron Valley Wesley Hospital, but funds again dried up. It was not until 1946, when the Benedictine Sisters stepped in at the request of Bishop Eugene McGuinness, that progress on the hospital resumed. Benedictine Heights Hospital opened in 1948, finally replacing the older, smaller Methodist hospital to the south.

The Benedictine Sisters had a long history in Logan County. Monk Ignatius Jean called for a school in the newly settled Oklahoma District, and encouraged by the Sacred Heart convent in Creston, Indian Territory, three sisters arrived from Iowa in September 1889. Thirty students of all denominations showed up to the Catholic school the day after the sisters came to town with the first class held in an unfinished wood-frame building.

Catholic education quickly expanded in the new territory. The fire at Sacred Heart prompted Guthrians to open a new school for girls west of town that was called St. Joseph's and became Benedictine Heights in 1948. It was later sold to the city as the home of the Job Corps. The sisters also founded a school for African American youths in Guthrie in 1896 and, forty years later, Claver College to provide higher education.

After World War II, the number of women initiating as Benedictine nuns declined. In 1962, as fewer sisters were available to serve in the hospital, the Diocese of Oklahoma bought it and made it into a branch of St. Anthony's in Oklahoma City under the latest name, Alvero Heights. By 1977, the building, which had already been renamed Logan County Memorial Hospital, was given to Logan County, which replaced it with a modern facility. The boarded-up building was purchased by a private concern with a bid to transform it into apartments, but the idea has yet to materialize.

Many reasons stand for why the building remains empty, including architectural instability and the restrictively massive overhaul required to turn into apartments. Rumors, however, whisper that the real reason is that the hospital is very much haunted.

There is no end to the ghost stories about the old Memorial Hospital. The most popular sighting is the ghost lights in the windows. Even though the building has been closed for nearly forty decades, people watching the building at night have seen something bright in the upstairs floors. Some say

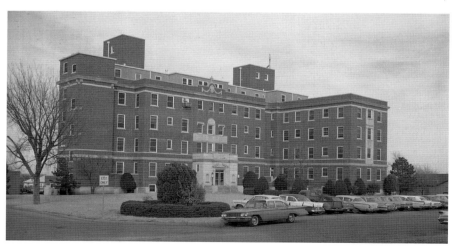

Logan County Hospital in the 1970s. *Courtesy Bob Bozarth Photography.*

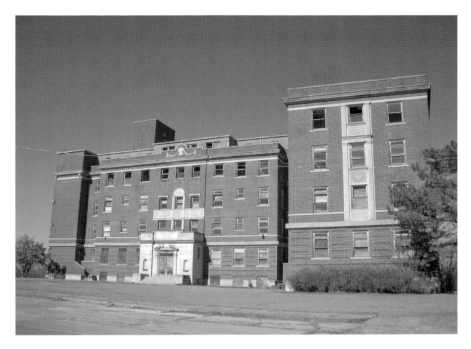

The abandoned hospital stands lonely today.

that the lights move from one room to the next, perhaps a nurse still making her rounds to check on patients long passed.

In addition to lights, which may be explainable as trespassers sneaking around, other stories claim that fully visible figures have been seen in the windows. One of the most common is a woman in a white dress with a folded hat, the kind worn by nurses in the early twentieth century. She is said to stare out the window, as if watching for something.

While ghostly figures are notorious for appearing in the windows, they have also been spotted throughout the building and even on the grounds. Time and again, people have called police or gone themselves to chase away someone walking on the private property, only to lose sight of the intruder. Usually the figures are difficult to describe, but those who get good looks at them say that they are nuns in full habits. Even those driving by in broad daylight have claimed to see the spirits of sisters still walking between the hospital and the garage behind it.

Many other figures at Logan County Memorial are said to appear. One is a woman in black, most often seen staring out the same windows where

nurses and patients are said to stand. While they seem more stoic than anything, this woman is described as having "evil eyes." She terrifies anyone who sees her.

More genial is the little boy in overalls who runs and plays throughout the hospital and grounds. Plenty of children visited the hospital through its many years. The Oklahoma state foster care system had several rooms reserved there as facilities where children could stay before transitioning to a new home. More infamously, the hospital had a floor dedicated to permanently disabled children, and many of those children are said to stay in their rooms to this day, not knowing that they should have passed on.

One of the ghosts said to lurk in the corridors of the closed-up hospital is Dr. Abraham Lincoln Blesh. He was a thin man with a thin smile who wore narrow, frameless glasses on his scholar's face between his pointed nose and high forehead. His appearance is unmistakable, and many point to his old picture, saying that Blesh was the figure they had seen.

While it is true that Blesh and Dr. Horace Reid began the original "little" Methodist Episcopal Hospital in Guthrie in 1910, Blesh did not practice at this later hospital. Blesh had come to Guthrie in 1893, transferring his practice from Kansas. He soon became one of the preeminent surgeons in the state, and he moved in 1908 to Oklahoma City, where he later became chief surgeon at Wesley Hospital, which still stands on Northwest Twelfth Street. During his career, he served as an army surgeon in World War I and the "Chair of Clinical Surgery in Epworth Medical School until its amalgamation with the State University in 1910," according to his "Who's Who" in the *Kansas City Medical Herald*. Afterward, he became the chair of the new school's surgery program. He died in his Wesley Hospital in 1934, aged sixty-eight, of inoperable lung cancer.

Apparitions are famous at the hospital, but there are far more strange stories. One of the most perplexing states that neighborhood dogs routinely visit the building. A short time ago, when a man raising dogs lived nearby, the canines would get out of their pens and head over to Logan County Memorial to sit on the front steps. Other dogs, some from homes blocks away, would meet them there and simply sit.

Rumors say that there is a hidden tunnel running from the hospital basement to the garage, and teenagers regularly dare one another to find it and sneak into the hospital, a dare that usually ends with a long chat with law enforcement.

With all of its visual activity, many people have tried to get inside despite the danger of their illegal explorations. Fortunately, in addition to its routine

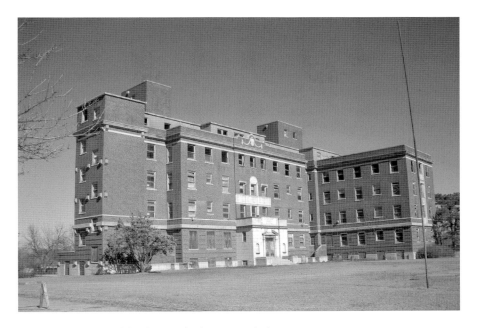

Ghostly figures are said to be seen in the upper windows.

firsthand investigations, the Oklahoma City Paranormal Research Group (OKCPRG), resolved much of the curiosity by installing streaming webcams throughout the building. For many years, the cameras rolled, catching several appearances as people logged on to watch.

Seeing the image of a specter is certainly one thing, but investigators say it is something else entirely to witness the sounds and sensations. Throughout Logan County Memorial, people have described hearing knocks and footsteps from rooms and hallways that are completely empty. More perplexing are the sounds of whole conversations as unseen patients talk to one another and music plays in the background. Of course, most fitting for the hospital are the disembodied coughs and screams.

CHAPTER 18
BENEATH THE STREETS

THE TUNNELS

One legend that seems to haunt Guthrie above all others is that of the tunnels. They are believed to crisscross town in a subterranean labyrinth that stretches for miles. Depending on who relates the story, the tunnels might just connect a few buildings downtown, or they could run from Mineral Wells Park to the Masonic Children's Home. Some of the tunnels are said to be narrow passages while others were big enough to let horse-drawn buggies roll through.

Several people relate stories of being down there themselves as youngsters, exploring with homemade kerosene torches. A common theme through them all is discovering old posters hanging on the brick-and-sandstone walls telling of plays in town or the circus visiting. Although numerous people have claimed to have picked them up during their youthful explorations, all the evidence is said to have been thrown away, disintegrated from old age or otherwise been lost.

A modern version of the tunnels story is that an employee noticed a hatch in the Ace Hardware store on Division and climbed down inside to find a subbasement where no one had been for years. The air was stale, but he decided to venture on and see how far he could go. After many twists and turns, passing by a series of other tunnels that had long been bricked up, he came to a final hatch at the end. There he popped out in the middle of the

Scottish Rite Temple, over a half mile away, and got into a fair bit of trouble with the Masons.

In his intensive study and search for the Guthrie Tunnels in 2013, Ron Jackson Jr. began at the Oklahoma Historical Society, looking for references to the tunnels in the state's extensive collection of documents and oral interviews. The search turned up negative. Nathan Turner at the Oklahoma Territorial Museum could find no reference even to the construction of tunnels. As far as state scholars are concerned, there is no such thing as the Guthrie tunnels.

Jackson went further with interviews of Guthrie city officials. The municipal service director and street superintendent both turned up empty-handed; the best they could offer was the big pipe of the city drainage system south of Jelsma Stadium. Former city manager Matt Mueller recalled, "One paranormal group even asked me if they could spend the night in the tunnels. I said, 'If you can find them, let me know. I'd love to see them myself.'"

Yet the legend lives on in unofficial conversation. Stacey Frazier believes that the overwhelming anecdotal evidence for the tunnels proves that there must have been something at some time. She says, "Old-timers have too many stories about getting from Point A to Point B underground."

Rather than a comprehensive system of tunnels, she thinks of them as "a series of interconnected basements that ended up stretching for blocks." Her grandmother told stories of casually walking through the tunnels to avoid the rain. One story mentioned a "ladies' lounge" that connected Oklahoma Avenue with the train station, giving the women somewhere to be while the men went to their own watering holes.

Another story told of a tunnel that ran under Harrison to connect the Brooks Opera House with the ravine to the south where an underground creek came to the surface. Theatergoers could drive their buggies down to park from the bridge over the creek and then walk the tunnel into the opera house's basement foyer.

At the very least, that tunnel would have been sealed up with the construction of Jelsma Stadium in 1936. Named for Guthrie businessman Lawrence Jelsma who championed its construction with support from the Works Progress Authority, Jelsma Stadium is a marvel of Depression-era engineering with a field that can be converted between football and baseball by swapping out the removable cages and field goals.

Today, Guthrie's stadium is routinely praised for its spirit and ranked by ESPN as the thirteenth-best high school football stadium in the nation, despite it being much smaller than state-of-the-art modern facilities. The

Jelsma Stadium, the pride of Guthrie football.

secret to its success is said to be its thirty-foot native sandstone retaining wall on the north end. Although built as a structural necessity in the landscape converted from a natural ravine, the wall works as a reverberator that echoes back the loud enthusiasm of the crowd. Even the stadium's nickname, "The Rock," was won from its unique architecture.

Jelsma rests at the center of many tunnel stories, such as tales told of a tunnel that ran under Harrison Avenue to connect it with the upper part of the ravine. It held pens along its sides for calves and bulls during rodeos on '89er Days. If such old legends were true, construction would have revealed the tunnels. Redevelopment in downtown Guthrie has already discovered numerous subbasements and stairwells that led to them, such as the one now serving Gage's Steakhouse in the Victor Building on Harrison Avenue.

Yet discoveries often fall as casualties to progress. A story related by former executive director of economic development Bob Thompson states that workers demolished Brooks Opera House and the Royal Hotel on Harrison in the 1960s. When they began tearing out the basement, they discovered a subbasement that had been sealed up for decades. The room inside was

The sandstone retaining wall stands eight feet above street level and some thirty-five feet over the field.

packed with card tables and roulette wheels. The stunned workers went to their foreman, who told them to just "fill that bastard in."

Perhaps many of the rumored tunnels do not appear on maps or in records because their creators did not want anyone to see them. Prohibition began in Oklahoma with statehood, a full decade earlier than the famed national restrictions on alcohol that began in the Roaring Twenties. Guthrie most certainly had its share of bootlegging, with any number of stills operating outside city limits and smugglers coming into town on a daily basis. Gambling often went hand-in-hand with drinking, and it is easy to believe that business went underground after the Reeves Brothers casino closed with statehood. All the eager customers would need is a place to meet.

One of the buildings often pointed to as a supposed center of secrecy is today known as Stables, where locals and visitors alike get a heaping plateful of small-town cooking. The menu serves customers' appetites for history as well as vittles, telling that the building originally served as E.E. Tallman's Flour, Feed & Wagon Yard. The Tallmans were sharp businesspeople whose livery grew into the largest in town. Everything related to horses, tack and wagons could be purchased or rented there. They were no strangers to progress and are famous for having the first telephone number in Guthrie: 1. When the automobile appeared, Tallman's soon added cab and bus services and a car dealership for Fords and Oldsmobiles. Daughter Alice Tallman gave driving lessons.

As a center for Guthrians and local farmers to congregate, the old livery was claimed to be a place to get a pinch of hooch. In 1917, Marion Gaines was arrested after a trio of young men from Oklahoma City drove up to Tallman's garage looking for whiskey. Tallman took them to talk with Gaines in the alley out back. Later that day, the sheriff spotted Gaines talking with the three Oklahoma City boys in their car. Gaines slipped them a package,

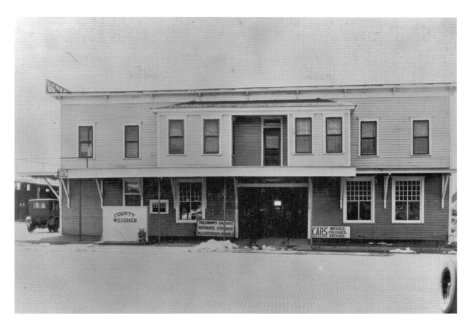

Tallman's Garage replaced Tallman's Livery as cars replaced horses in Guthrie.

and the trio handed him some money. When the sheriff searched the car, he found a quart of whiskey inside. Gaines was convicted but got an appeal based on a court error. Tallman was exonerated as having no direct connection with any of the evidence.

Today, Stables is a bustling business once again, constantly packed with hungry customers. Although the supposed connections with bootlegging have ended, spirits of the supernatural kind are said to haunt the upper floor where the Tallmans once lived. It is said that unearthly drumbeats may be heard, in addition to various tales of objects moving by themselves. The origins of such sounds are as mysterious as the building's own history.

Some may point out that clear over-ground cases of bootlegging might eliminate the need for smuggling tunnels, but others still say that tunnels in Guthrie existed for legitimate reasons. There are said to be numerous hatches all over town to the legendary network, including an entrance on Cottonwood Creek that Stacey Frazier said she explored. Like many of the others, this entrance is long sealed up from overgrowth and erosion.

Whether the tunnels existed and have been gradually filled in or never existed at all is still a matter of great debate. Some believe that a conspiracy by city officials in generations past scrubbed the history of the tunnels from

Today the renovated garage hosts Stables Café.

the books. Another theory speculates that officials simply don't want people skulking around where they might get hurt and hold the city liable. The only way to be certain about the existence of the tunnels would be to pull up the very foundations of Guthrie and check.

If the tunnels were discovered, it wouldn't be the first time a treasure was pulled from underground in Guthrie. According to the *State Capital*, in April 1895, almost exactly six years after the Run, a man called on a farmer asking to seek buried treasure on his farm five miles south of town. The farmer obliged, perhaps bemused. The man went out on his search and soon returned with an outstanding offer of $900 for the farm. It was tempting, but the farmer was determined to stay. After the refusal, the man left town. The only thing left behind from the mysterious man was his dropped pocketbook.

Someone took a look inside, finding a letter written a month earlier by John Litchfield to his cousin Joe. John's father had left in his estate a map to buried treasure, which he had left behind in Indian Territory in 1869 as he crossed to New Mexico. It sounded ridiculous that someone would leave behind gold and silver, but Joseph McNeal of the Guthrie National Bank

and a few friends decided to take a look. They returned to the farmer's place, followed the directions on the map from the stump of an elm tree and began to dig nearby. Their digging revealed an iron pot filled with $500 in silver and $4,500 in gold, which was quickly returned to the bank's vault to determine the rightful owner.

CHAPTER 19

TRULY HAUNTED HOUSE

GUTHRIE SCARE GROUNDS

A short drive north past an old bridge to the outskirts of town takes adventure-seekers to one of Oklahoma's leading haunted house attractions, the Guthrie Scare Grounds, the center for the Guthrie Haunts group of horror enthusiasts. During the month of October, people line up, anxiously waiting to get inside to experience the thrills and chills of the Halloween attraction. Clowns, bugs and zombies wait around every corner to frighten those who seek a fun scare for the season.

Few people realize that this particular haunted attraction is truly haunted. There is a high rate of turnover among workers, not because of long hours, but because of the strange things that happen there. One young woman mentioned that she had been on break, resting a few minutes before heading back out to scare people. She received a scare herself when the soda bottle set aside by a co-worker leaped up from the ground and flew across the room, as if someone unseen had kicked it. The tale is one of dozens shared among the employees.

The full history of the building is still somewhat of a mystery to us, but we do know that it served as a steak house at one time and another time as apartments. A woman who once resided in the apartments claims she always felt like it was haunted. She and her husband often heard footsteps late at night and even heard gunshots from time to time. We

have been unable to locate any information of anyone passing away on the site, so we wonder why this particular building is said to be haunted. Is it perhaps someone attached to the land, or could it be a former passenger attached to the old hearse sitting in front of the building? We may never know why this location plays host to so many spirits, but the haunting is obvious.

There are several entities that reside at the Scare Grounds, but there are three that like to make their presence known to investigators on a regular basis. One of the spirits that often likes to come out to play goes by the name "Emily." Emily is a young girl between the ages of seven and nine with long curly blond hair. Many people report feeling a child-like presence walking beside them, as if someone short was just beyond the edge of vision. On several occasions, people have jerked up their hands in surprise when they felt small, unseen fingers tuck around their own. Emily appears to be a curious child and enjoys when people come to visit. She is quite active and lets her presence be known.

That is, until the man shows up.

This second male spirit that comes around is said to be mean and will show himself as a dark shadow figure. Whenever he presents himself, people often report a heavy, dark feeling as well as the sudden onset of a headache. The tormentor gives negative sensations that send many people out of the building, whether a show is going on or not.

The third spirit is that of a woman. She tends to appear more for the owner John Pagonis than anyone, especially when he is remodeling the building for the next attraction. He called me up one day to report that she appeared in front of him only to pass right by.

We have been investigating the Scare Grounds for a little over three years now. Like most places, paranormal activity levels vary depending on many different factors. Whenever an investigator walks into the dark spaces of the building, he or she may immediately feel a presence, but one night in particular seemed more active than ever.

It was one of our Guthrie event nights where we invite guests to join us as we investigate several of the old buildings around the historic Guthrie district and up to the Scare Grounds. This particular night, we had a large group, so we decided to break into five groups with each one being led by a seasoned investigator from our team. The groups rotated through five buildings that night. Other spots might have been quiet, but when the first group visited the Scare Grounds, they were shocked at just how scary Guthrie Haunts could be.

As we entered the building, many people felt a dark, looming presence all around us even before the investigation began. Whenever we take a group into a site, we always do a walkthrough with everyone so they can get an idea of the layout of the building. A few people barely made it into the walkthrough when they decided they simply couldn't handle investigating this location. They excused themselves to wait outside while the rest of the group continued on.

People entering the building are greeted by multiple rooms decorated in different themes. They vary from the baby doll room, with multiple baby dolls scattered on the walls and floors, heads and limbs torn off, to a room filled with scare-clowns on through to a room covered with bugs. Toward the back of the building is a life-sized graveyard diorama with tombstones, bare trees and a coffin.

As we took our place along the wall of the graveyard, equipment in hand, we started our EVP session. We asked if there was anyone with us. The ghost radio said, "Emily," in a quiet child's voice. Many of our guests were impressed and eager to interact with the charming spirit of a little girl.

Later that evening, a darker presence returned, as if it had followed us. The ghost radio started saying words like "get out" and "murder." Those who had stayed felt nervous or outright sick and now understood why others had waited outside.

Not long after the threats began, it was time to rotate. The next team obtained the same type of responses. Again, a couple of our guests decided to wait outside because of the uncomfortable feeling in the building. More activity continued throughout the night, including shadow figures and disembodied voices. Guests were shocked, but it was little more than the staff there experiences on a regular basis.

Over the years, many EVPs and pictures have been collected of the various spirits that reside in the Scare Grounds. Whether as a haunted house attraction in October or a paranormal investigation throughout the year, Guthrie Haunts continues to provide the thrills and chills of a modern haunted location among the many in the historic town of Guthrie.

BIBLIOGRAPHY

BOOKS

Benson, Ned Harold. *The Ancestors and Descendants of John Lewis Benson and His Sisters and Brother: A Genealogy and Social History*. Bloomington, IN: AuthorHouse, 2007.

Guthrie Oklahoma Territorial Directory. 1903.

Hudson, Cullan. *Strange State*. Dallas, TX: Whorl Books, 2007.

James, Louise Boyd. *West Wind Views*. Woodward, OK: West Wind Publishing, 1989.

Lentz, Lloyd. *Guthrie: A History of the Capital City, 1889–1910*. Guthrie, OK: Thirty Seconds Over Tokyo Studio, 1990.

McGuire, Lloyd H., Jr. *Birth of Guthrie: Oklahoma's Run of 1889 and Life in Guthrie in 1889 and the 1890s*. San Diego, CA: Crest Offset Printing, 2000.

Osage Hills Detective Stories. Guthrie: Oklahoma Territorial Museum, 2014.

Review of Industrial & Commercial Guthrie Directory. Logan County, 1910.

Tolson, Abraham Lincoln. "A Negro in Oklahoma Territory, 1889–1907: A Study in Racial Discrimination" Diss. University of Oklahoma, 1966.

Wilson, Steve. *Oklahoma Treasures and Treasure Tales*. Norman: University of Oklahoma Press, 1976.

ARTICLES

Arkansas City Daily Traveler. "A Shooting Affray." August 7, 1889.

Balyeat, Frank A. "Oklahoma University at Guthrie." *Chronicles of Oklahoma* 37, no. 3 (1959).

Edwards, Dena. "Old Victorian House Haunts Guthrie." *Distinctly Oklahoma,* October 1, 2011.

Gaines v. State. 18 Okl.Cr. 525. Oklahoma Court of Criminal Appeals, 1920.

Greiner, John. "Legislature to Meet Today at Guthrie's Convention Hall." *Daily Oklahoman,* April 19, 1989.

Guthrie Daily Leader. "The Ghost Still Walks." April 19, 1896.

————. "No More Ghost." April 23, 1896.

————. "Was She Buried Alive?" April 8, 1896.

Guthrie Leader. June 25, 1893.

Guthrie News Leader. "Grand Leader Sold." August 29, 1904.

Helbig, Jack. "Where On Earth Is Allen Ross?" *Chicago Reader,* October 15, 1998.

Jackson, Ron J., Jr. "Mystery of the Guthrie Tunnels Still Thrills Today." *NewsOK,* 2013.

Kersey, Jason. "Why Guthrie's Jelsma Stadium is the Oklahoma City Area's Best High School Football Venue." *Oklahoman,* November 2, 2011.

Kirkendall, James. "Masonic Home for the Aged—Guthrie Oklahoma." *Arkansasties,* May 23, 2014.

Oklahoman. "Voodooism Being Revived by War." October 27, 1918.

————. "'Witch Doctor' Reaps Rich Harvest Among Negroes at Guthrie." August 27, 1918.

Oklahoma State Capital. "Peculiar Death Recalled." June 9, 1907.

"110 Years of Masonic Charity in Oklahoma." *Oklahoma Mason* 66, no. 5 (August–September 1998).

Raymond, Ken. "Stories of the Ages: Endangered Black History." http://ndepth.newsok.com/black-history/guthrie.

Sarchet, C.M. "Unusual Stories of Unusual Men." *Rotarian,* May 1927.

Sutter, Ellie. "Guthrie Link to Koresh Seen as Possibility." *Daily Oklahoman,* October 16, 1993.

Thoburn, Joseph B. "Frank H. Greer." *Chronicles of Oklahoma* 14, no. 3 (September 1936).

"Who's Who in the Southwest, and Why." *Medical Herald, The Kansas City Medical Index-Lancet.* January 1911.

WEBSITES

"A Harvey House Homepage." http://www.harveyhouses.net.

Guthrie Scottish Rite. http://www.guthriescottishrite.org/.

Izard, Bill. Porter Briggs. "Guthrie's Elbow." http://porterbriggs.com/guthries-elbow/.

King, James L. Shawnee County KS Archives Biographies: Guthrie, John 1829. http://files.usgwarchives.net/ks/shawnee/bios/guthrie56nbs.txt.

"Logan County Hospital." Abandoned Oklahoma. http://www.abandonedok.com/logan-county-hospital/.

Loudenback, Doug. "Vintage Oklahoma City—Epworth University." http://www.dougloudenback.com/maps/vintage_epworth.htm.

"Ponca City Information—About—History Tid-Bits—Louis Hanes Wentz." www.poncacity.com.

Stone Lion Inn. http://www.stonelioninn.com/.

ABOUT THE AUTHORS

In 2009, Tanya McCoy joined her first paranormal team located in the Oklahoma City area as co-founder and remained with them until 2011, when she decided to form her own team. In 2012, she joined forces with Investigating Oklahoma's Paranormal (IOKP) founder Dee Parks to form Oklahoma Paranormal Association (OPA). OPA was formed to help teach new paranormal enthusiasts proper techniques to conduct paranormal investigations. Tanya and her team continue to do private investigations for homeowners and business owners who may be experiencing paranormal activity.

 In 2009, Jeff Provine founded the OU Ghost Tour, a charity walk telling spooky stories of campus. The university visitor center has made it a formal tour, and Jeff has led more than three thousand guests across campus to tell tales. Since then, Jeff has been nicknamed the "Ghost Guy" and has written two collections about ghost stories in Cleveland County, *Campus Ghosts of Norman* and *Haunted Norman, Oklahoma*. He works as a curriculum developer, writes speculative fiction and teaches courses such as the History of Comic Books. Visit him at www.jeffprovine.com.

Visit us at
www.historypress.net
..
This title is also available as an e-book